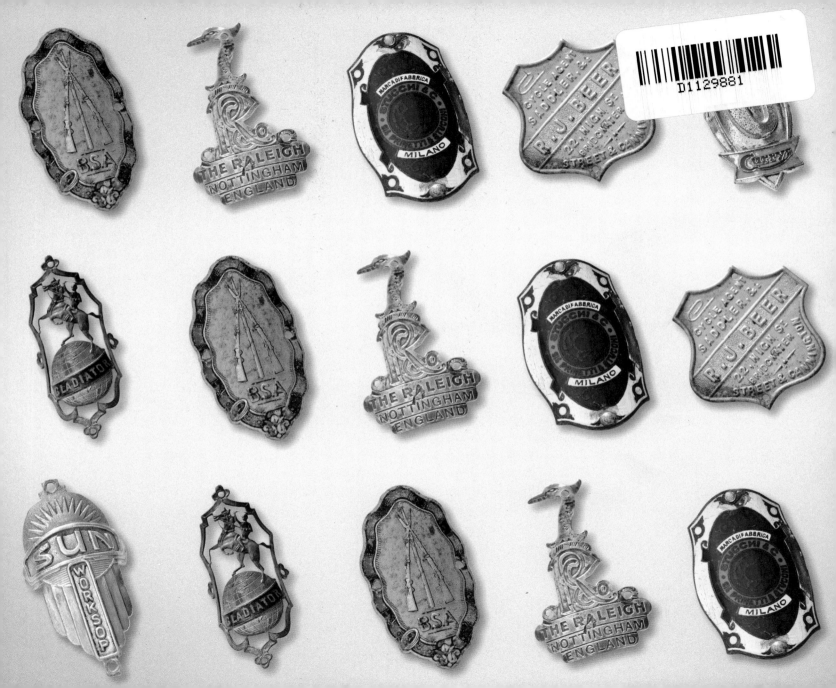
D1129881

my cool bike.

# my cool bike.

an inspirational guide to bikes and bike culture

**chris haddon**

photography by **lyndon mcneil**

PAVILION

# contents

CENTRAL ARKANSAS LIBRARY SYSTEM
ROOSEVELT L. THOMPSON BRANCH LIBRARY
LITTLE ROCK, ARKANSAS

# introduction

Imagine, if you can, a world without the bicycle, a world where your basic choice of transport is between walking and the internal combustion engine. Then imagine what a revelation it would be if someone came up with the idea of fashioning two wheels in alignment, powered only by human effort. Such a person would be hailed as a genius (and would become very rich indeed).

Thankfully, the bicycle has been around for a long time, and it's an invention we should all be grateful for. Because for a lot of us, life wouldn't be the same without our nostalgic youthful memories of owning a bike. Entering a bike shop, lunging towards your bike of choice, ignoring the nose-tingling smell of rubber and metal but marvelling in the knowledge that you're 'gonna have more gears than wotsisname down the road!' Strapping torches to your bike ready for the onset of darkness; placing a strip of cardboard in the spokes of your wheel to emit a noise that, for you alone, mimicked the sound of Evel Knievel's motorcycle! Circumnavigating the roads where you lived for countless hours at a time, varying your direction just as an excuse to turn the handlebars a different way and give your equilibrium a chance to level out! The epic fun of barrelling down inclines nigh-on out of control, gripping the handlebars for grim death! I'm sure by now you've guessed these are the musings of an ageing thirtysomething. However, despite not being a gambling man, I'd put money on the fact that I'm striking a sentimental note with many of you.

So maybe, matching the simplicity of an invention dating from the 1890s, when the bike became a utilitarian form of transport for the masses, it's a connection to the simpler times of our youth that has kept the bike an enduring – and endearing – part of our lives. Despite all our modern advances, still the bike resists being sidelined, remaining a pastime enjoyed by millions from all walks of life.

Bikes are cool! High-profile cyclists are now rightfully accorded superstar status and their names are uttered in the same breath as A-list celebrities. Cycling is no longer the preserve of the folk you once tried to avoid. If reports of the ever-increasing numbers taking up the pastime are to be believed, cycling is riding atop the crest of a popularity wave with no sign of faltering. Boutique bicycle shops, cycle cafés, fashions (not just Lycra) and a plethora of other spin-offs have erupted as a result of cycling's resurgence in popularity.

You may already have a highfalutin bicyclette, skinny-wheeled retro classic, deep-rimmed trendsetter, city shopper, penny farthing, bargain basement or jumble find. Or maybe you're still searching for that special 'something' – a vintage companion with built-in pedigree – avoiding at all costs a run-of-the-mill off-the-shelf bike. What better time to explore the wealth of cycling cultures that exist in abundance?

Sure, cycling has pitfalls – you're at the unprotected mercy of Mother Nature, impatient fellow road users and despicable bike thieves. However, for the duration of this book let's set aside those negative thoughts, especially as they're far outweighed by positives. Cycling, by definition, is clean and green, enjoyable, social, relatively cheap, a quick form of urban transport, undeniably good for you – and it's all held together with a strong camaraderie.

Looking back at the photographs compiled for this book, it seems like only yesterday I was faced with the challenge of selecting the best stories and images with which to fill this book. My net was cast worldwide in search of content; I had to – it was the only way to do justice to a subject that has true global coverage. The aim: to capture a fleeting moment of those who've pushed the boundaries of personal achievement by undertaking mind-boggling challenges, or those acknowledged for their sporting excellence. For some, their challenge is changing perceptions of the humble bicycle through alternative, sometimes artistic uses, while others show the humorous, passionate and at times crucial part that bicycles can play in people's lives. Then there are the collectors, designers, clubs, proprietors and individuals for whom a bike is an extension of their style, or an opportunity to express creativity by way of customising their bike.

Between us, Lyndon and I travelled to London, Paris, Bruges, Amsterdam, Cornwall, Scotland and New York. With assistance from other talented photographers, the net was cast even wider to Beijing, Iowa, Tennessee, Oregon, Italy and Africa. The individuals appearing between these pages are genuine enthusiasts, with a true passion for bikes. Everyone and everything, where possible, was photographed in their natural guise and environment (apart from the round-the-world cyclists – a re-enactment wasn't really a fair request).

On occasions, we've departed from photo-shoots humoured, amazed or humbled – sometimes all three – mentally digesting as best we can what we've seen and heard. But I can say with confidence that for Lyndon and myself it was a pleasure producing this book. Accordingly, we're extraordinarily grateful to the people who gave their time to make *my cool bike* a reality. The underlying narrative of the book is that cycling appears to transcend discrimination by way of race, gender, age, wealth or class; it's a true social leveller. My only regret is that I never managed to get my mother-in-law to learn how to ride a bike. For some reason this talent has always eluded her...sadly, some things are just not meant to be.

You may be a seasoned all-round *rouleur* or an aspiring one; someone looking for a healthy leisure activity or a way to combat a costly commute; or perhaps you're seeking a way to travel and explore places in a more intimate way – which only cycling can achieve. Maybe you're in search of a pastime where the goal is solitude, a cathartic process for the mind by following the rhythm of two spinning wheels. Perhaps you see it as an artistic conduit or a way to meet new people, becoming part of a community of like-minded individuals. Whatever you're looking to achieve, this book does not intend to be judgemental...my hope is only that you enjoy it and that it encourages a new inspiring and refreshing perspective to bike ownership.

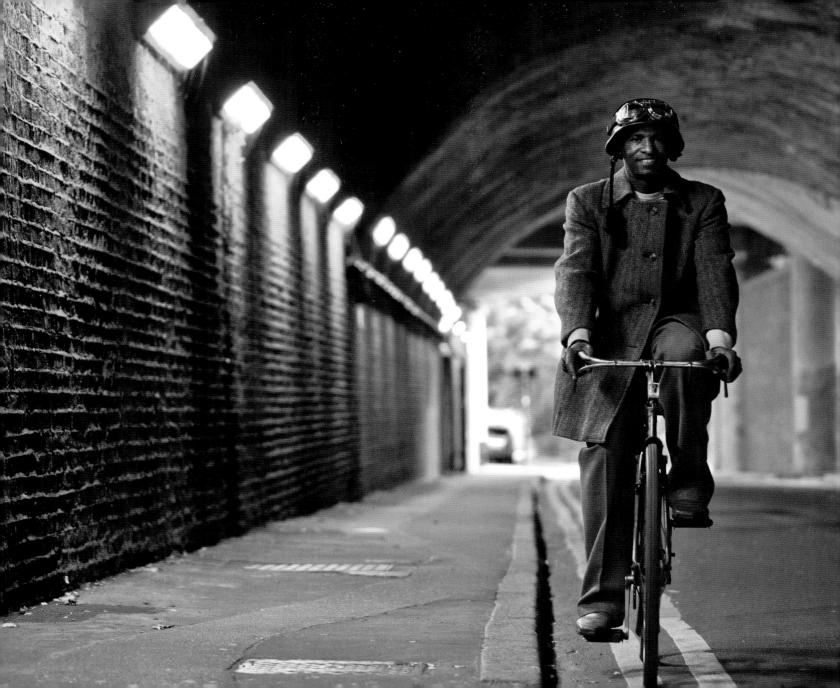

new york

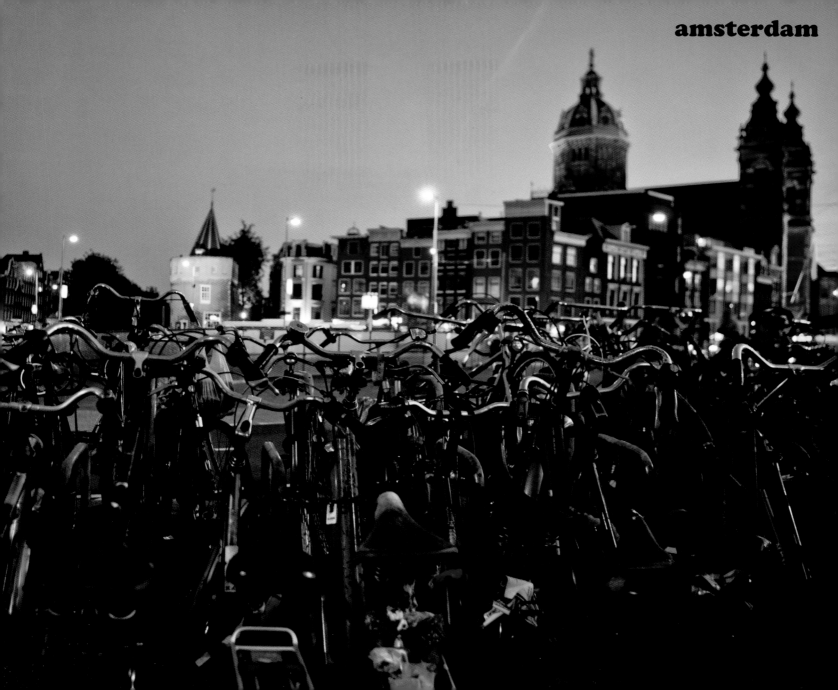

amsterdam

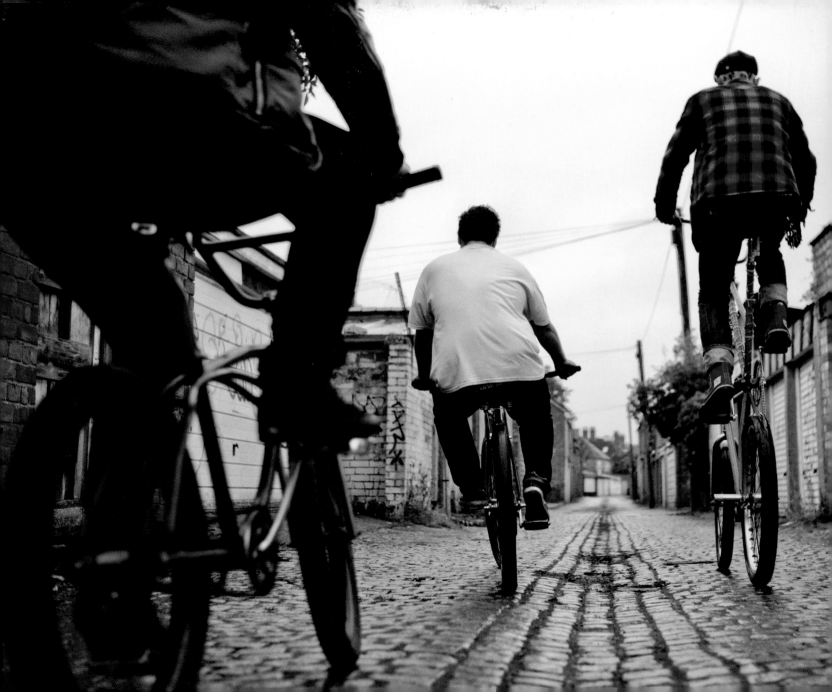

# bringing together

When delving into the subject of bikes, it's impossible to overlook the feature that runs through it all – the 'bringing together' of kindred spirits who relish with a passion all that cycling offers. This passion spills over into an ever-evolving culture with spin-off trends, and each time new people take to the saddle, further strengthens the cycling community.

Bike culture and attitudes to cycling vary from place to place and it's evident that some are further advanced than others, for example Amsterdam, with its roots so deep in cycling that cars play second fiddle to the needs and rights of a bike. For some, bike ownership has moved beyond a recreational activity to become a way of life.

The devotion exhibited by Briggy at his bike shack shines through. Bikes may be at the heart of his business, but his motivations go far deeper by way of his underlying attitude to helping and giving time to others. This commitment takes his shack far beyond a humble bicycle repair shop into the realms of becoming an important hub in the community.

The bicycle emporiums featured offer a sought-after quality of service from a bygone era, where you will find those who tailor a bike to the rider's exacting needs, plus a craftsman designing the perfect urban mode of transport.

The camaraderie of collectives such as the Thursday Club, who despite their advancing years refuse to take life at a slower pace, is inspiring, especially at a time of life when a comfy armchair and slippers would find favour over a 40-mile excursion for most. Then there is the magnetic draw of the Ministry of Bicycles, attracting individuals from all walks of life in order to dabble with bicycles on a weekday evening. Not forgetting a dapper bunch that favours 'pace with grace' and a Brooklyn bike club whose members pander to their pride and joy.

Throughout this chapter are opportunities to explore the many wonderful facets of cycle culture that help those brought together through their love of bikes remain together.

# briggy's bike shack

'In any other guise my shack just wouldn't be the same,' explains Briggy, who after moving from the Bahamas in 2002 established his bicycle repair service 'Briggy's Bike Shack'. Briggy, with his laid-back Caribbean vibe, now works in a space far from ordinary – a storage area set aside for stalls from the local market – just a stone's throw away from London's Waterloo station.

'Don't go expecting state-of-the-art facilities. Instead you'll find a place with a real passion for bikes. Visit my shack and use my tools – no charge. If I can do something for free, I will – for some a bike is their only form of transport. Recently I rescued some bikes from a skip – it took minimal effort to get them in working order before I gifted them to some people I knew who were in need of a helping hand. Terrible business sense, I know. However, payment doesn't always have to be in a monetary form. Too many people let money rule their life. Satisfaction for me is sending someone on their way after having done a good deed – hopefully what goes around comes around.

Briggy repairs and sells pretty much anything he can get his hands on, from vintage to nearly new, from fixed gears to racing bikes.

'I love people dropping by my shack, it's treated much like a bike-themed community centre. Local businesses donate food for my regular homeless visitors, who know they'll always find something to

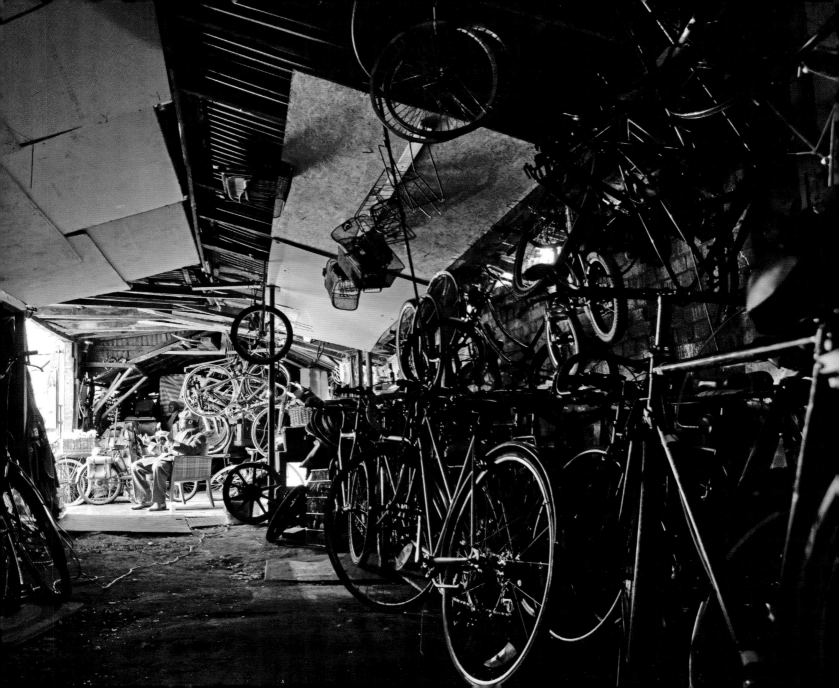

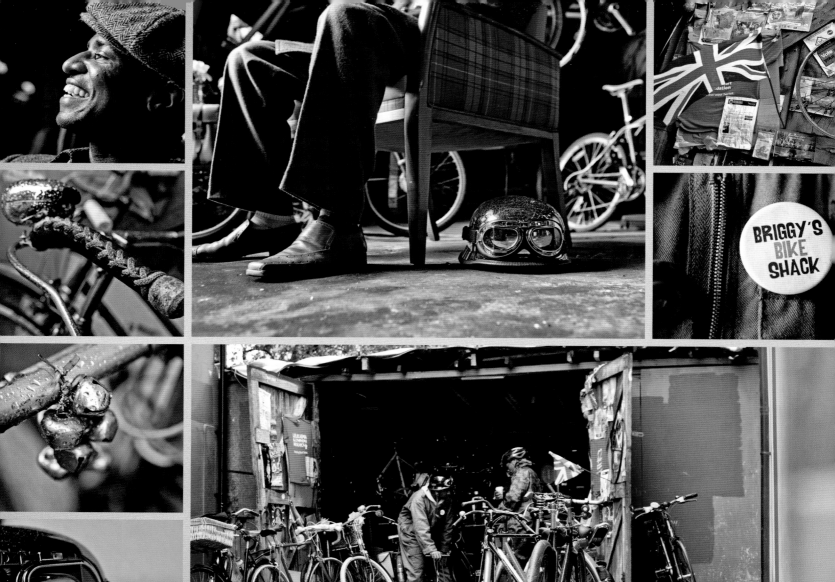

BRIGGY'S BIKE SHACK

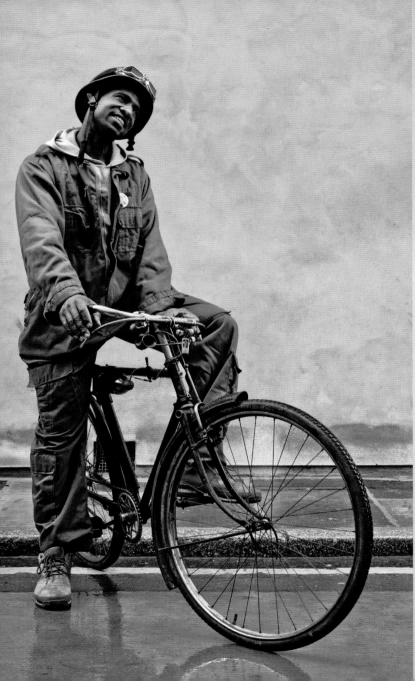

eat and drink. My words are real, I've time for everyone, all I do is treat people well by showing them love and respect.

'I don't fit squarely into a niche of cycling style. I race on a semi-professional, Lycra-clad level. However, I'm no stranger to ditching my Lycra and overalls when participating in London's annual Tweed Run on my trusty – but very heavy – 1920s Raleigh bike. It's a solid piece of machinery that's the polar opposite of my carbon-fibre racing bike.

'I fear my days here are numbered. It would tear me apart to leave; however, my being here is nothing more formal than an off-the-record agreement. The area is changing, my shack doesn't fit in with those plans. You can take the shack away from me, I won't hold a grudge – but you cannot take my passion or enslave my beliefs that are inside of me...they're mine.'

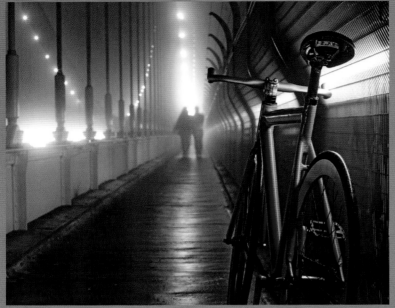

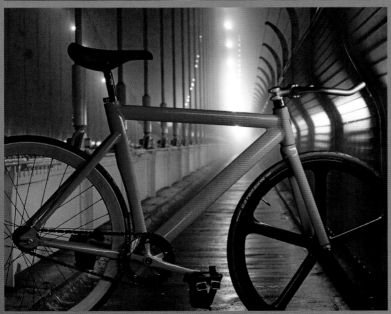

# fixed 'n' chips

'Bewilderment turned into curiosity and then to obsession,' says Gavin Strange, senior designer and art director for the digital arm (or, more accurately, Plasticine arm) of Aardman Animations. 'It started when a friend took delivery of something called a fixed-gear bike. I was intrigued as to how this pastel-blue Bianchi could be so beautiful without all the "bits" on it. After persuading me to have a go, I reluctantly and cluelessly pootled up and down the road in varying degrees of terror! I initially dismissed the bike based on the fact I couldn't coast...however, the bike's pure simplicity and possibilities for customisation appealed to my design tendencies. Five years later I'm a convert, with three immaculate *objet d'art* fixies, including "Liberace 2: The Phoenix" – bigger, better and pinker than "Liberace 1", my first bike, which was sadly the victim of theft.

'I'm a fan of casual riding rather than epic distances or speeds. Therefore I organise a weekly event called the Chip Shop Ride. We all meet in the centre of Bristol, cycle a leisurely distance and end up at a chippy for a chat. That spawned FIXED'n'CHIPS, an alley cat race for fixies only with the same relaxed ethos that is based on points rather than times. The first rider to reach any of the five chip shop checkpoints receives ten points; second, nine points, and so on. However, the riders can elect to stop at a checkpoint and wolf down a battered sausage (or mushy peas) for an extra five bonus points. A tactical ploy, as the champion may not win because they're the fastest overall...instead they may take a steadier pace and enjoy a deep-fried snack at every checkpoint!

'I'm just doing my bit and putting another tick in the box for Bristol's diverse cycling community!'

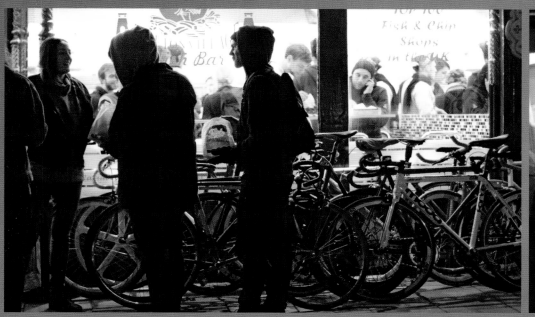

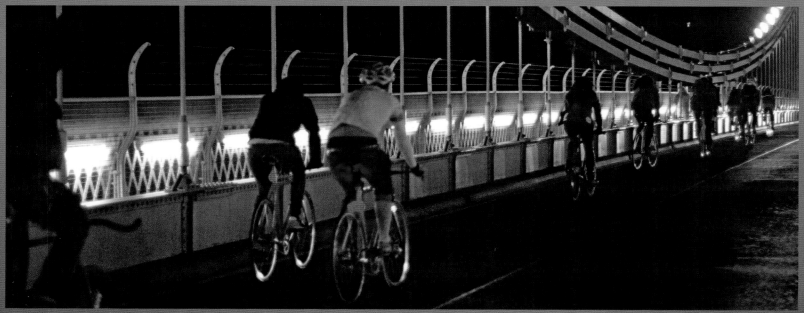

# the thursday club

'An honest mistake and not an indication of my fondness for a good red wine,' admits John Rhodes – ex works racing driver. 'When, like all good things in life, my racing career came to an end I was invited to join a cycling club, which I thought was called the "Thirsty Club". Initially it sounded like a great idea – pubs, fresh air and bikes. Alarmingly during my first outing, after passing several watering holes I learned it was in fact the "Thursday Club" – not a pensioners' cycling pub crawl! Much to my relief I soon learned that at least one pub visit was always included en-route, setting us up for the 40-mile or so ride over the myriad of country lanes which spread out over Shropshire. John gets around on a fairly basic town bike, but his clubmates ride a variety of cycles, from classic models to more modern steel-framed machines.

'Members are a mixture of ex pro-cyclists (no Lycra for me, slacks, shirt and cravat are more my thing) and seasoned cyclists all of whom, in the politest

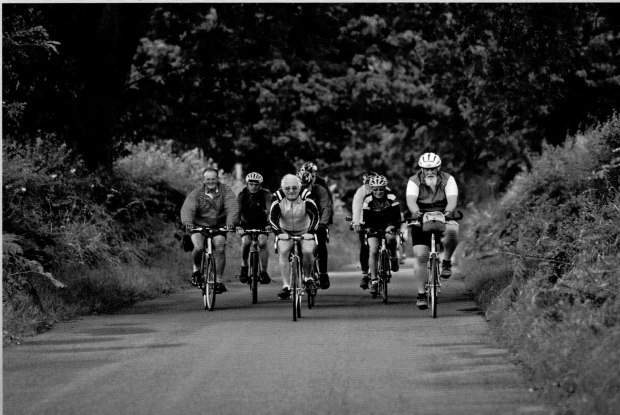

term, are senior in years. Our youngest member is 55 and most senior 93, so at 85 I'm no spring chicken, but still have plenty of miles in the old legs yet. My wife insists I take a mobile phone in case of emergencies, which was all well and good until I did fall off and landed on the phone – promptly flattening it.

'We keep things informal and only have minimal rules: no women (not politically correct nowadays) and you can die on a Thursday – but don't have your funeral on a Thursday, as that would spoil a good day's cycling. Macabre, yes, but you have to laugh about these things at our time of life.

'The club has been going strong since its formation in 1977 by Eddie Shingler and Norman Hazelock. Sadly neither are still with us despite both cycling until well into their nineties. Each year on Eddie's birthday his daughter provides us with a bottle of whisky and we raise our glasses in remembrance of those comrades who have permanently taken off their trouser clips and gone before us to where all good cyclists go!'

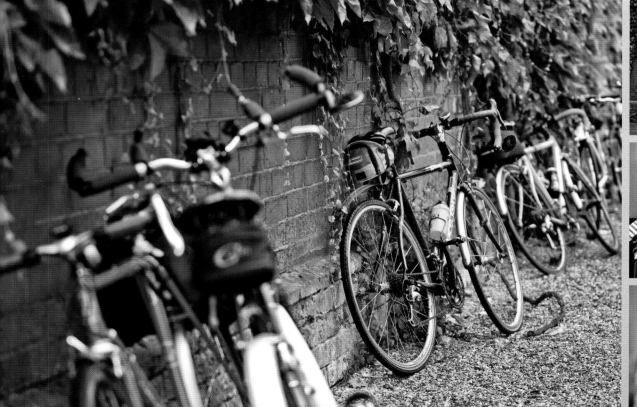

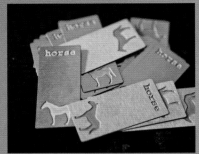

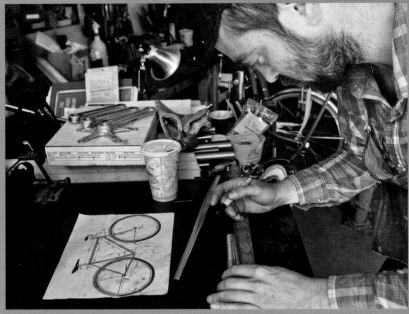
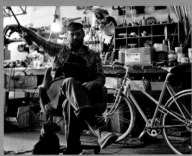
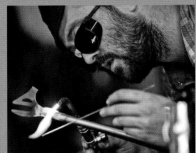

# horse cycles

'My aim is to make each bike different from the next by exploring new avenues of design. It's a pleasure to be part of the intimate process of working with a customer when building their new bespoke bike,' explains frame builder Thomas Callahan from Horse Cycles in Brooklyn, New York.

'Before I established Horse Cycles, and began frame building, it never crossed my mind to fathom out where bikes came from or how they were made..."bike fairies", I guess? But being a hands-on kind of guy I learned how to build them and now it's my life.

Describing himself as a 'guide' to help his customers choose every component and design detail of their bike, Thomas takes around 20 measurements from each client and also watches them ride their current bike and asks what they like and dislike about it. A unique cycle can then be crafted for each customer.

'My inspiration for Horse Cycles stems from my love of the American West and old cowboy movies. It's about the freedom of movement: not being dependent on cars or public transport; just having the ability to go, at the drop of a hat, where the mood takes you, as well as the positive effects on the mind and body. By building bikes for others I hope they too can experience the same pleasures that I enjoy.'

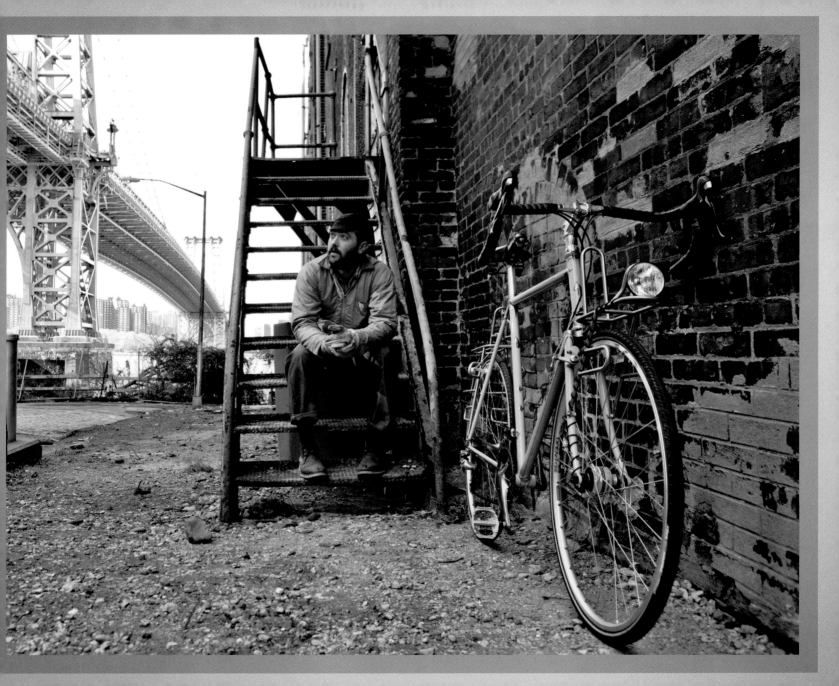

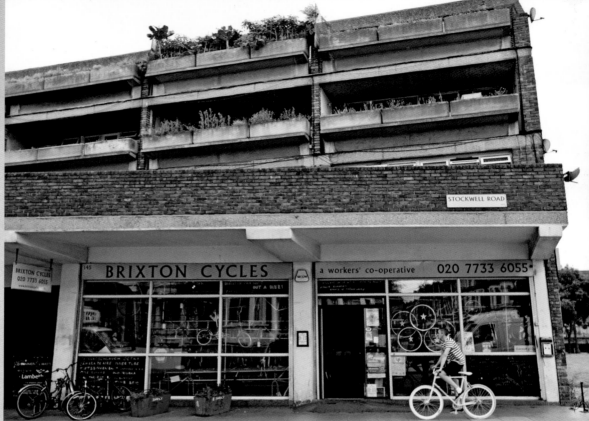

"AIR IS FREE"
SPREAD THE LOVE

WORKS
WITH
PRESTA
-THIN-
AND
SCHRADER
-FAT-

PULL EVER UP WHEN ON VALVE

# the co-operative

Early 1980s Britain, and in particular the London district of Brixton, was in the grips of recession and rioting – hardly the best time for launching a business venture. Undeterred, three cyclists, Tim, Tom and Paul, disillusioned by other bicycle establishments, decided to open a shop catering for people as passionate about cycling as themselves. Nigel from Brixton Cycles explains: 'In 1983, helped by a start-up grant from the now defunct GLC (Greater London Council), the workers co-operative, Brixton Cycles, was opened in Coldharbour Lane, an area which, at that time, could hardly be described as "up and coming" by even the most imaginative estate agent.'

Tough times followed, but with support they made it through the formative first few years, carving out a reputation as an honest shop selling quality products with excellent repair skills. Nancy then joined the trio and, with a mid-80s cycling boom triggered by

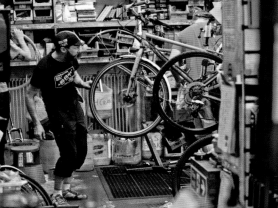

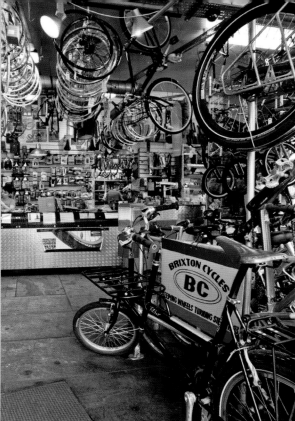

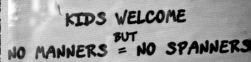

KIDS WELCOME
BUT
NO MANNERS = NO SPANNERS

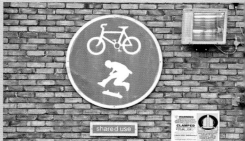

shared use

the arrival of the mountain bike from sunny California, Brixton Cycles pushed on. By the 1990s, however, three of its pioneers had moved on to new – mostly bike-related – careers, leaving a lonesome Paul to carry the flag with a team of part-time workers. Later followed the new generation of co-operative workers. In 2001 they relocated next to what the locals call 'Brixton Beach' (Stockwell Skatepark).

Nigel continues: 'At the moment there are 13 of us – all with a true enthusiasm for bikes. No original members remain – Paul hung up his shirt in the 90s. There are no hard and fast rules for our successful co-op; everyone has the same pay, same say, equal rights and equal responsibilities. So, don't go asking for the boss – they're too expensive, not very efficient, hardly much fun, not necessary and we don't have one.'

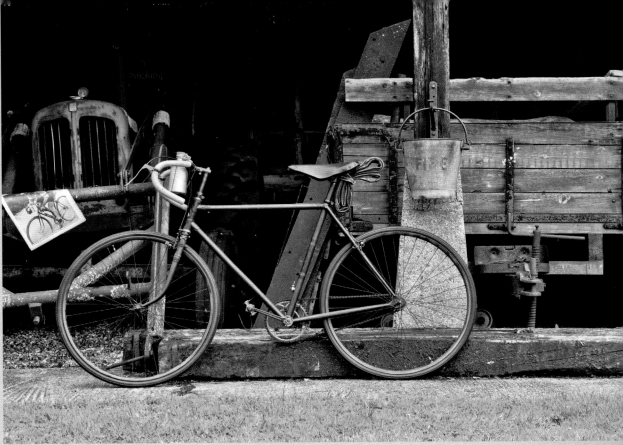

# the old bicycle company

Spread over a series of barns in the Essex countryside is The Old Bicycle Company. It's a treasure trove of bicycle delights – a sheer bike lover's paradise. Owner Tim Gunn explains, 'I know I have too many bikes, but as fast as I sell them I get offered more!'

Tim's bicycle fascination started as a child. With his father being a car restorer, there were trips a-plenty to shows displaying cars and bicycles. 'Many collectors struggle to keep their collections under control and there's a tendency for things to overstep the mark – I'm only just on the right side.

'I've bikes from the late 1880s upwards. However, if confronted to make a decision to pick one, and only one, it would have to be what at first sight appeared to be a run-of-the-mill French town bike, which was offered to me for sale by another collector. I knew it was something interesting, although its then pedestrian disguise, namely straight bars and mudguards, hid its sporting pedigree. Despite having nothing to back up my hunch,

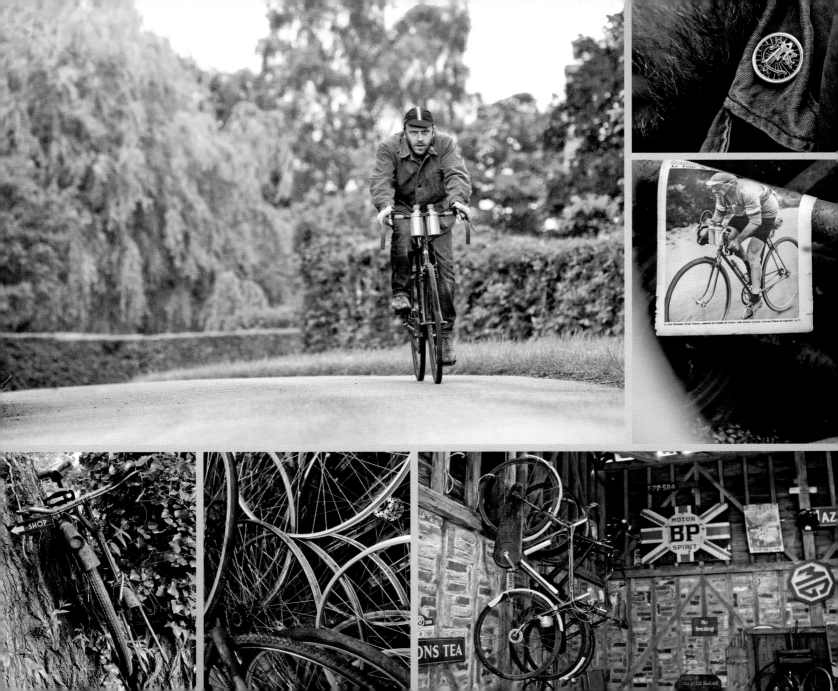

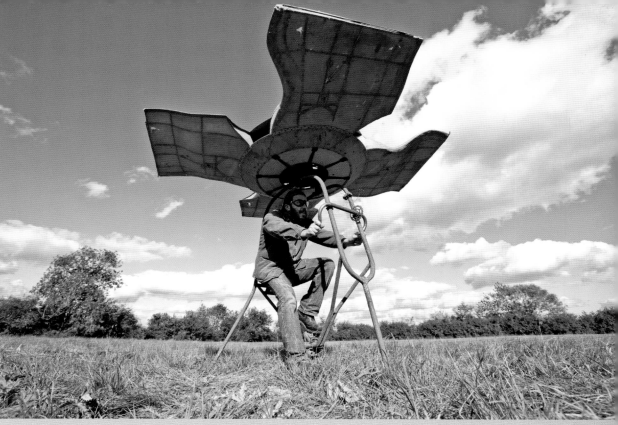

I purchased it, then after research discovered it appears to be a racing bike used in the Tour de France by Victor Fontan in the late 1920s.'

With only a single fixed gear it's a far cry from its modern-day counterparts. Back then, when racing downhill, aided by a flip-flop bike hub, the rider had to first dismount and flip the rear wheel to allow for freewheeling.

'On occasions, with gusto, I remove everything from the barns with the full intention of sorting and cataloguing. However, the pile of "to keep" and "to go" always favours keep – so what comes out always goes back in. Similarly what goes up must come down, which brings me neatly on to my latest acquisition – namely my pedal-powered helicopter, which dates back to goodness knows when and was found in a French attic – goodness only knows how it got there! I just couldn't let it miss out on being part of my collection. Work is needed before an air-worthy certificate could ever be issued, if in fact it's ever been airborne! But I'm going to give it a jolly good try.'

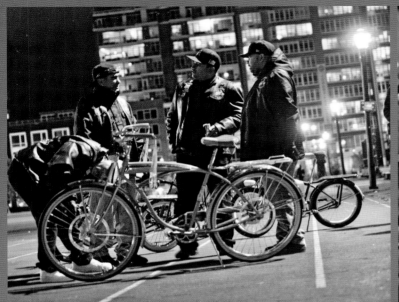

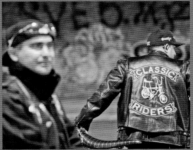
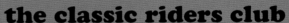
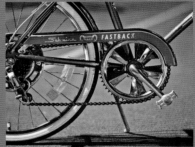
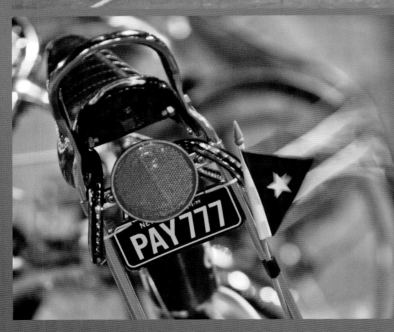

# the classic riders club

On jackets and vests their club emblem is proudly displayed. For club president Eddie and members of the Classic Riders Club (Elia, Jessy, Tacatan, Jorge, Betto, Javy and Bill), ownership of a Schwinn bike brings with it a sense of pride and tradition. Club members can often be seen frequenting various clubhouses across New York or cruising the streets on impeccably restored original or tricked-out bikes – often lavishly accessorised with rare components, horns, bells, streamers and radios.

Founded in Chicago in 1895, Schwinn went on to develop many innovations in cycle design, such as the streamlined 'aerocycle' and the 'spring fork'. Such a vintage brand may seem an odd choice for the Latino community, but as Eddie explains, 'Within the Puerto Rican community of New York there exists an appreciation for vintage Schwinn bicycles. This stems from the time we were living in Puerto Rico where there was once a Schwinn factory. For those who could afford a bike a Schwinn was the obvious choice. So when we came over to America we would take our Schwinn bikes along to the annual Puerto Rican parade and gradually it became part of our tradition. For many of us our bikes are more precious than gold!'

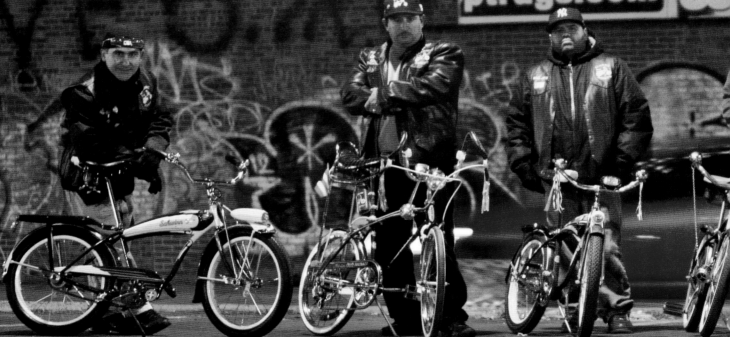

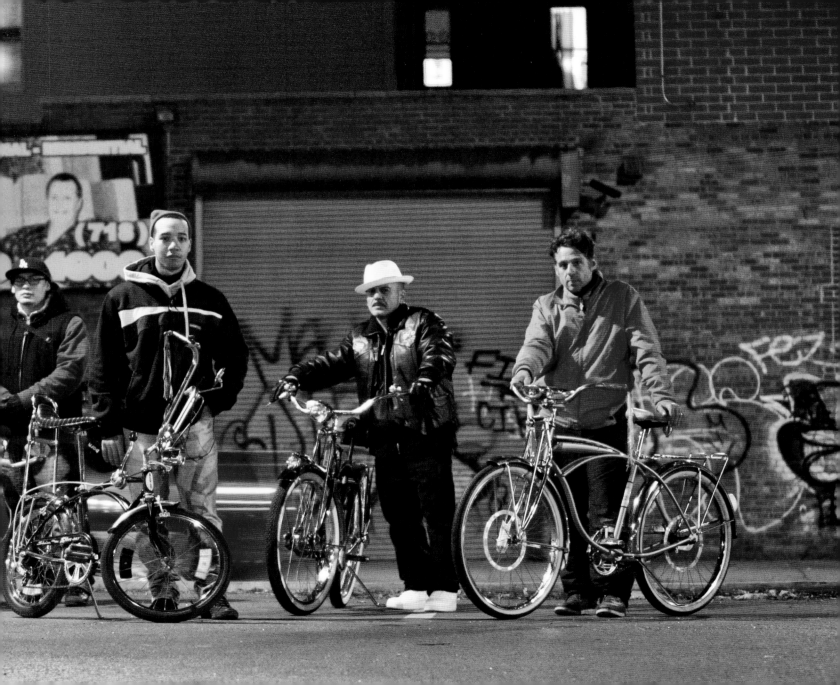

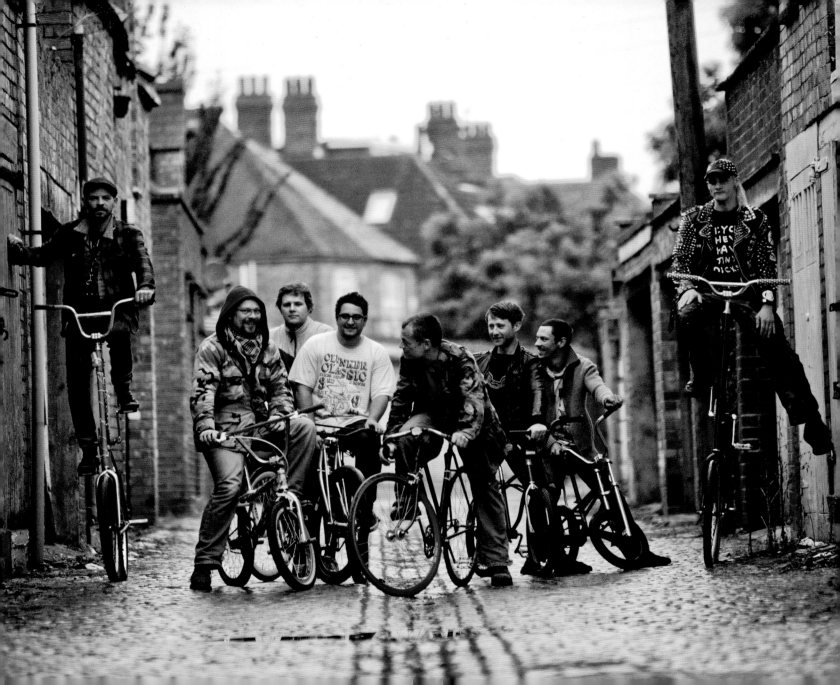

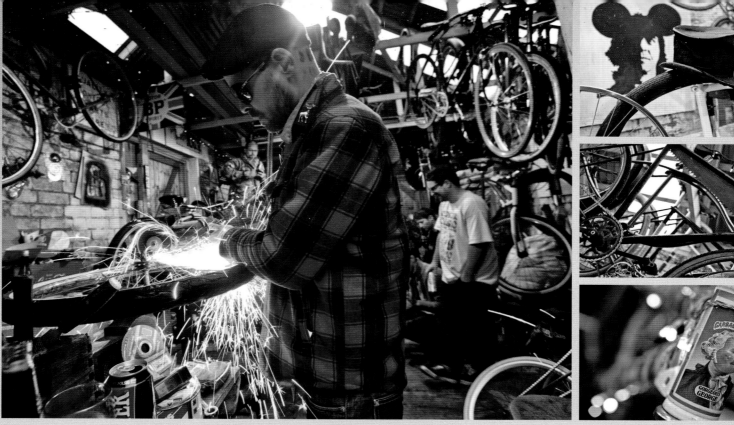

# the ministry of bicycles

'MNIPN – "Monday night is project night" and a time for other bike shenanigans,' explains Bill. Despite what the name may imply, he and his collaborators are not civil servants of a government-run operation – far from it. In fact, as Bill comments, 'I would challenge any government to try and govern what we do! Monday nights are a mixture of rowdy banter and bike-related tinkering, all from within the comfort of what has become affectionately known as "The Shed". Said shed was once the studio used by my late father, a sculptor who's responsible for some amazing works of art – in fact, both my parents have strong artistic tendencies. My mother is an acclaimed painter, which I guess, in part, is why myself and my brother, George, just can't help concocting one-off freak bikes assembled from several bike frames and various parts that overspill the confines of the shed.'

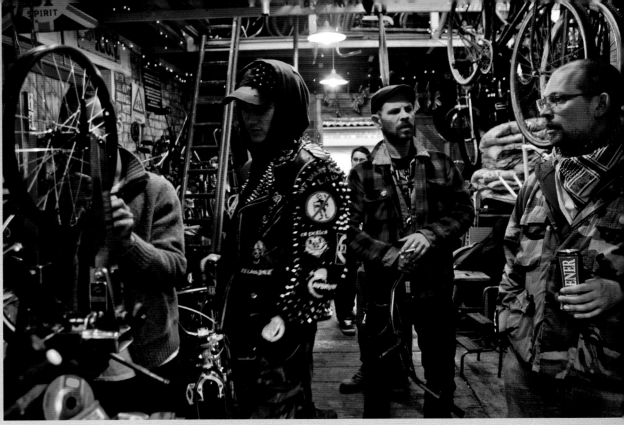

Those who attend the Ministry stem from different walks of life – from resident punks Paul and Davey to a clerk of courts, gas engineer, electrician, computer programmer, surveyor, designer and a martial arts teacher. The one unifying factor that brings them together is a love of two-wheeled human propulsion, and Monday nights are a whirl of respoking, adapting and changing parts – plus, of course, the occasional welding together of frames to create their lofty 'freak bikes'.

One evening the Ministry hatched a plan to build what is now known variously as The Bowl Of Harm, Bicycle Wall Of Death or The Bomberdrome. Whatever you call it, there's no getting away from the fact that the wood-slatted, 26-foot-diameter, pedal-powered death trap is not for the faint-hearted. 'Everything in your mind is telling you it's wrong – very wrong. However, it's one of the more interesting results from our Monday nights.'

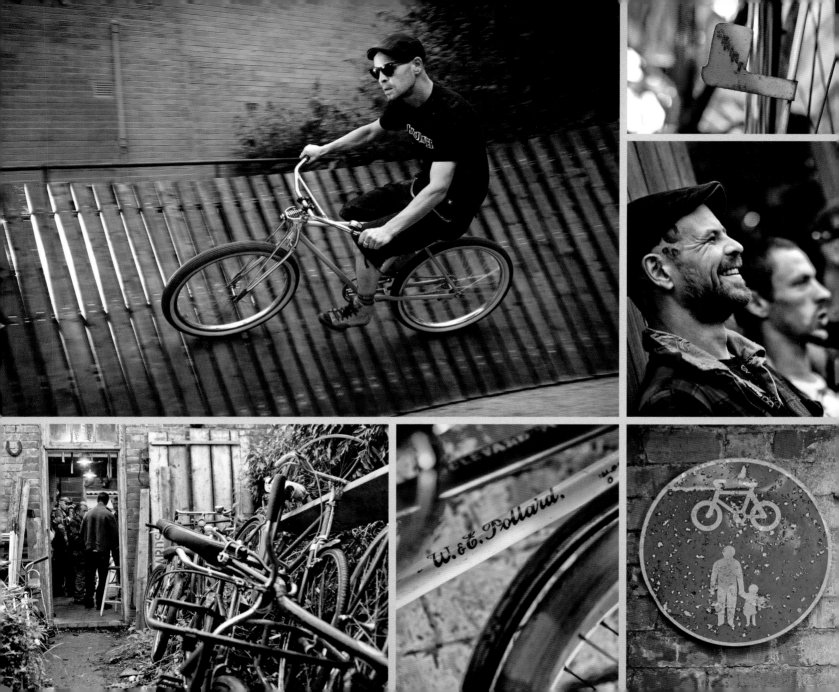

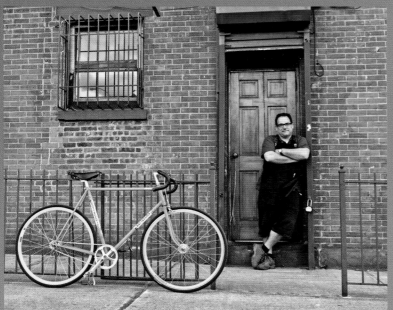

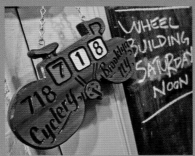

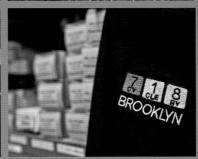

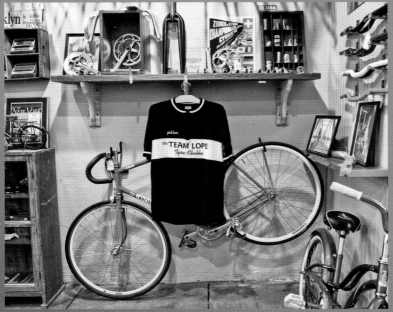

# the inverted bike shop

'We're now becoming widely known as the "Inverted Bike Shop". After years spent in front of a computer, building in virtual reality, I woke up to the fact that I actually needed to build with my hands again,' explains architect Joseph Nocella from 718 Cyclery in Brooklyn, New York. 'We're not here for you to select a bike that you have to conform to – vice versa. Over discussions, a blueprint of wants and parts to suit the individual is drawn up to build a bike that conforms to you.' This involves taking a range of measurements on a special device called the Calfee Size Cycle and a detailed process of component selection involving the customer at every stage. 'Then comes the process of assembly, in which the client is invited to participate and experience the formulation of their bike. It's not just a purchase...it's an experience.'

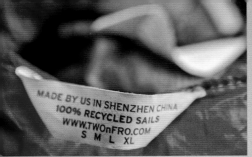

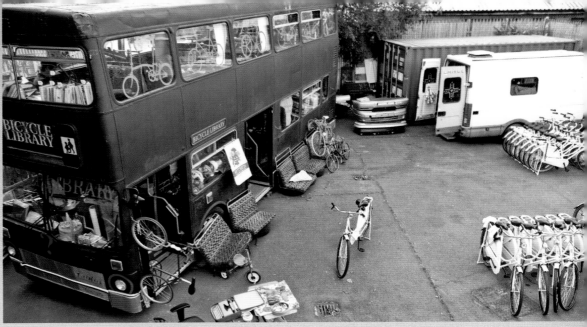

# the bicycle library

'Tickets, please! As well as being an inspiring choice and versatile space for my clothing range and bikes, Maggie, my much-loved 1980 metro bus, has one obvious bonus – mobility. It's a unique selling point that a regular bricks-and-mortar shop can never match. As and when events dictate, or when we feel like a change of scenery, we can up sticks and relocate lock, stock and barrel,' explains Karta. Originally from Portland, Oregon, Karta is an industrial designer conjuring up cunning design solutions for the modern-day city cyclist.

'What should a library offer...a place to broaden your horizons; research; learn about something new and leave informed – ready to make a decision based on fact. The Bicycle Library emulates that philosophy. For a small fee we lend you a bicycle from our signature range – enabling you to make an informed choice. We offer seven styles of bike: folding, mini velo, fixed-gear single speed, ladies' coaster, men's coaster, cargo and electric. Unfortunately, for many, purchasing a bike is just a matter of going to your local industrial estate and picking one out. Many factors are at play and should be explored before making a purchase. The right choice keeps you on the road longer and, most importantly, comfortable.

'My fashion label TWO n FRO offers a range of clever design-led cycle clothing and accessories. City cycling is not without its hazards, so to aid rider visibility many of my designs incorporate reflective qualities. I spend several months a year in Shenzhen, China, at my own workshop where everything is handmade from only recycled sustainable materials such as Kevlar, boat sails, parachutes and bamboo.

'And my own personal bike...well, through experimentation, for me it's a bamboo-framed fixed-gear bike with its unique flexibility that serves me best on London's streets.'

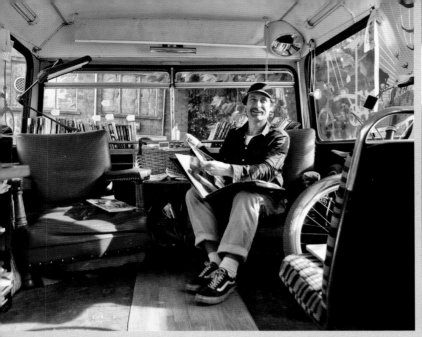

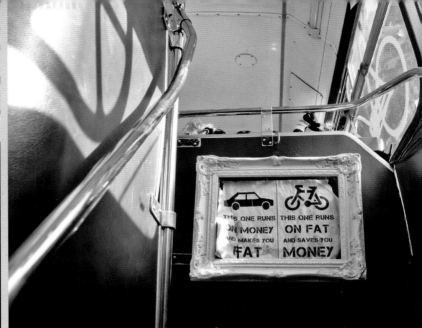

THIS ONE RUNS ON MONEY AND MAKES YOU **FAT**

THIS ONE RUNS ON FAT AND SAVES YOU **MONEY**

TheBicycleLibrary.com

£1

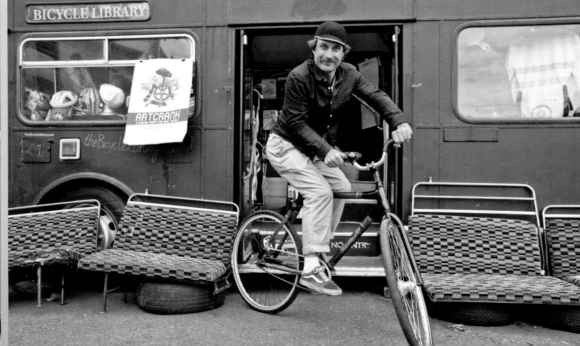

BICYCLE LIBRARY

ARTCRANK

theBicycleLibrary.com

£1

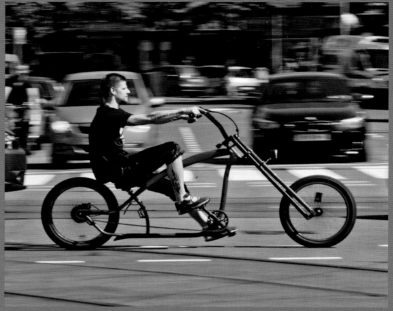

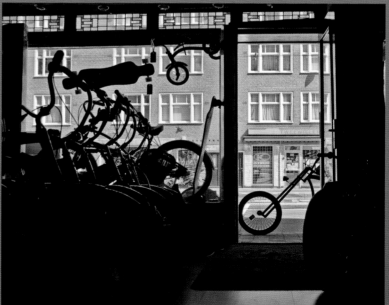

# chopperdome

Chopperdome: a mecca for Amsterdammers in search of a chopper, lowrider or one-off custom bike. The 'retro choppers' with their extended forks and laid-back seat tube angle resulting in the classic *Easy Rider* position, are very popular in Amsterdam, where their extra weight is less of a handicap on the flat terrain and high speeds can be reached.

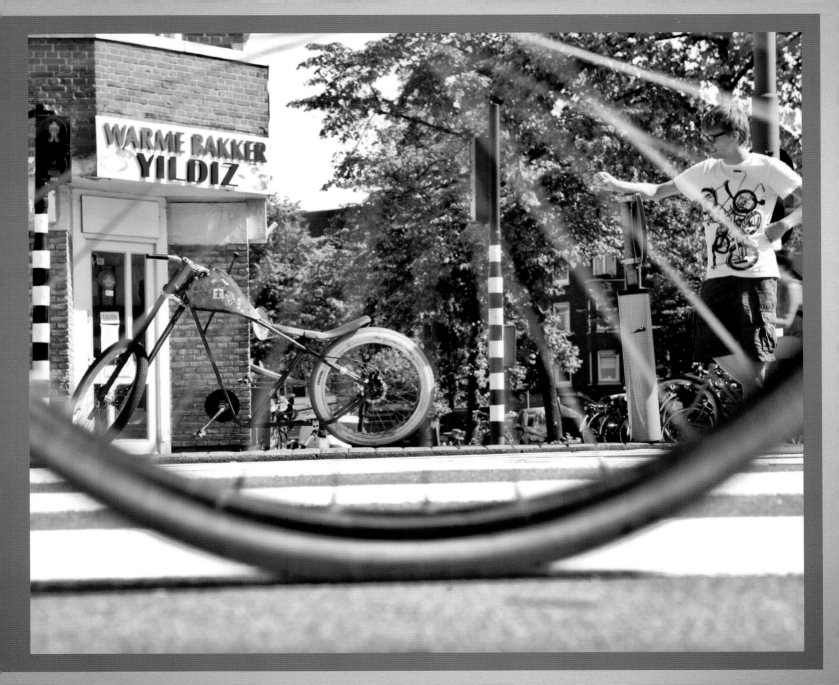

# sargent & co

'I found the 1951 Hobbs racing bike among undergrowth in a friend's garden,' explains Rob. 'I saw it had potential and after negotiations swapped it for a three-speed Sturmey Archer wheel. Diligently I took it apart with the full intention of restoring it to its former glory. I got distracted by one thing or another and soon independence beckoned and it was time to leave home. The bike, still in pieces, remained languishing in my parents' shed. Some years later an ultimatum – "the shed's collapsed, come and get the bike quick if you want it" – was issued by my mother. By the time I got round to exhuming my bike from its wooden tomb my mother had thrown away many of the parts – despite denying, to this day, all knowledge of her actions. From that day for the next thirty years the frame followed me around from pillar to post like a lost puppy – I couldn't part with it, despite it never being even close to rideable. Whenever I moved, somehow it always got bundled in with my belongings and brought onwards to the next location.

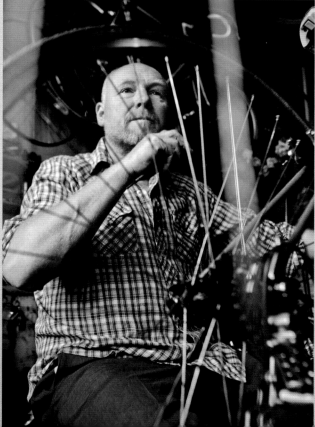

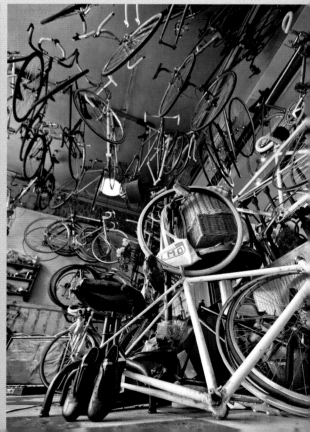

'A friend introduced me to the vintage bike scene and with his help we got the bike back on the road. At this time I was a photographic artist. Having spent three enjoyable years in a darkroom I felt it was time for a change of direction, to be less of an "artist" and become more of an "artisan". My interest in vintage bikes and cycling was increasing exponentially. So hatched an idea of a commercial space in which I could live, surrounding myself with my ever increasing collection of bike frames and doing what I loved by day – to sell and repair bikes. It remained just a dream until fortuitously a series of events – including an eviction – put the wheels in motion. Thus came about Sargent & Co.

Rob is now famous for his collection of unique steel-frame vintage racing bikes from some of the best frame builders around, all with beautiful period detail.

'To me, the language of bikes is so evident through handmade frames. You can really see the art in bikes, subtle differences which to most would go unnoticed. From the front-fork rake to the detailed design of the lugs – each is a trademark to the frame builder.

'My Hobbs frame now rests among the many others in my "not for sale" collection, all of which dangle from the shop's ceiling, like a steel version of the hanging gardens of Babylon.'

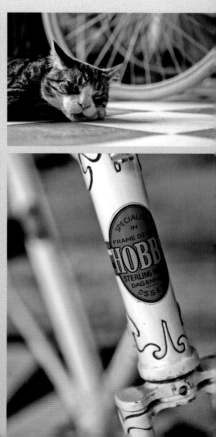

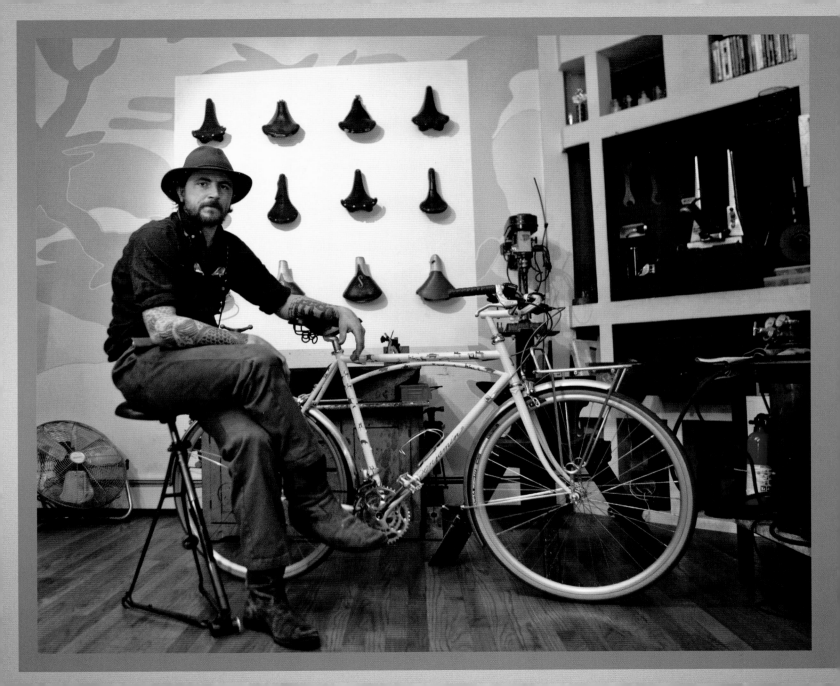

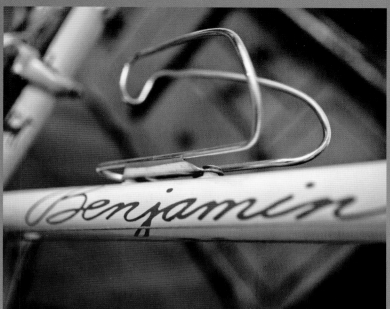

## benjamin cycles

'I run a small business called Benjamin Cycles that specialises in custom, steel bicycle frames that are all handmade in Brooklyn, New York. My bikes and design practices are influenced by the museums and contemporary art galleries I visit,' explains Ben Peck. 'My frames are engraved, no two are alike. With every bicycle I build, I try to break design limits, making something truly beautiful and innovative.

'Cycling is just something I happened to fall into at a young age and never grew out of. I love riding my bike just as much now as I did when I was five. However, I wish I could still ride my bike in my underwear, cowboy boots and Superman cape – but even in Brooklyn I'm sure I'd get arrested.

'I've never thought of bike riding as a lifestyle. I don't ride to be healthy, though I guess it helps. I don't ride to compete and win trophies, though I empathise with those that do. I don't ride to help save the environment, but it's awesome that I am. I don't ride because I hate traffic – I actually don't mind it much, especially when I'm able to pass everyone with ease. I don't ride because I hate cars – hell, I wish I had a 1966 Lincoln Continental Convertible. I ride because it allows me to take in the world at a slower pace and be a kid again.'

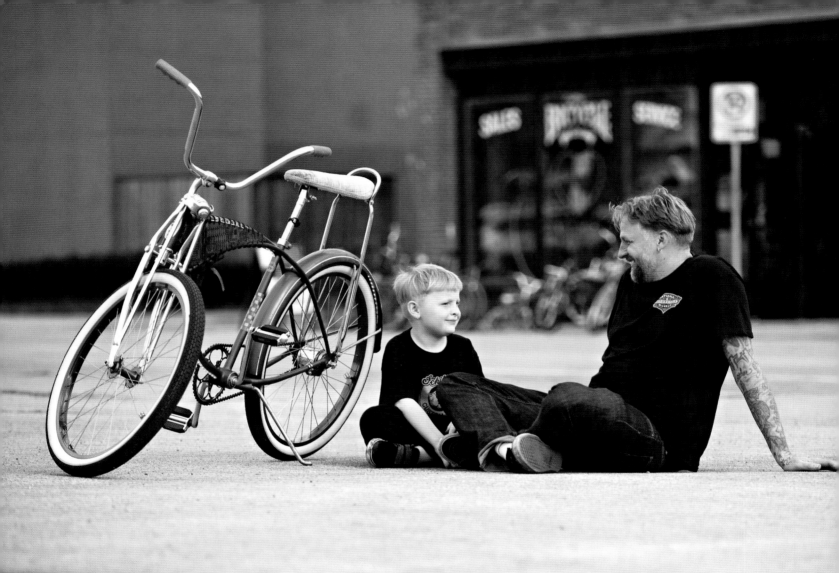

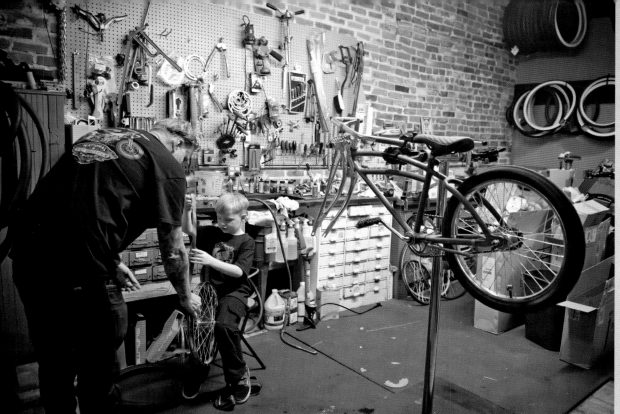

# ichi bike

'I love art, bikes, tattoos, low-brow and high-brow culture. If I'm hanging with hippies I'll play punk rock, if I'm with punks I'll play hippy music – I'm a man of contrasts. As a kid growing up in Iowa I yearned for the "Cali" way of life,' explains Daniel Koenig, an artisan of custom vintage bikes.

In 1983 Daniel moved to California; a year later he returned home, having been exposed to the 'cool' California lifestyle and all it had to offer! After further schooling he went back to California and became a punk-rock bike messenger. Then he moved to Maui with nothing more than a backpack, skateboard and bike – before going back to San Francisco, then over to Barcelona and up to Amsterdam. After a somewhat nomadic lifestyle he finally settled in San Francisco and began working for tattoo legend Ed Hardy. During these life-affirming years bikes played an important part of his life.

In 1997, with a body suit of tattoos, I was back in Iowa and running my own tattoo studio. With success there is much excess! However, after a few turbulent years, with help, I was able to sort myself out. By 2005 life was great; I became a father to my son

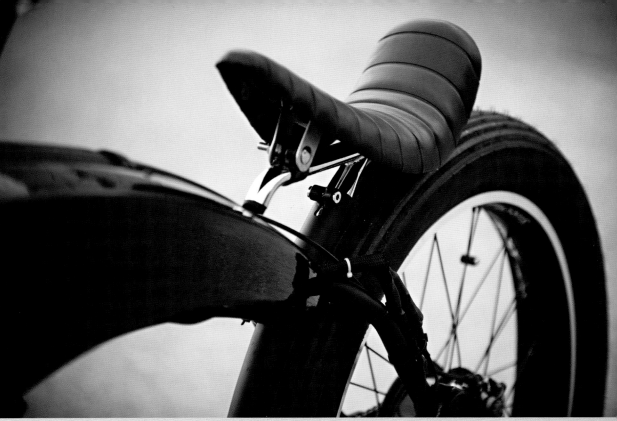

Isaac, stepfather to Helen and a husband to my soul mate Amy. With such a rich past and so many diverse memories to draw from I was looking for a new realm of expression.'

Daniel's enthusiasm for bikes in general increased, as did customising them. To make something more formal he established 'Ichi Bike'. 'The backbone of the business is the Rat Rod style bikes I create – "Rat Rod" coming from the fact that, like a rat harvests food left in dumpsters, I salvage bikes and repurpose them.

'At times I contemplate how people could've become so detached from what was once their pride and joy, enough for them to have so easily discarded it, dismissing the history captured forever within the tubular frame. Factors obviously dictate what can be deemed a functional bike. However, there's a moment in the artistic process when the bike seemingly tells me it's done or I can see clearly that it's at the peak of perfection.'

Daniel has no 'favourite' brand of bike; if he sees potential in a cycle – be it retro, classic or vintage – he will do his best to bring it out and give it a new lease of life. With the occasional help of his son, he gets the chance in a small way to be part of a person's life through something that was once a cherished item, creating bikes that are blank canvases to which new memories can be applied.

# star bikes café

A variety of traditional Dutch-style bicycles available for rental means that visitors to the Star Bikes café can experience first-hand the unique cycling culture that Amsterdam offers.

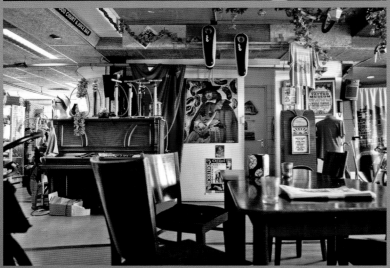

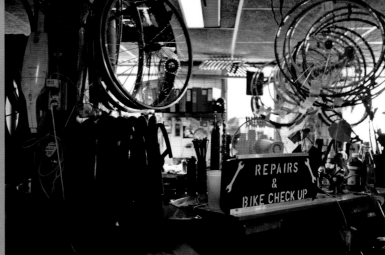

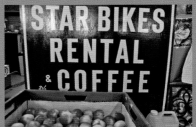

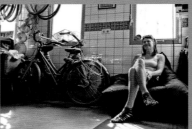

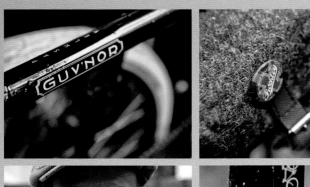

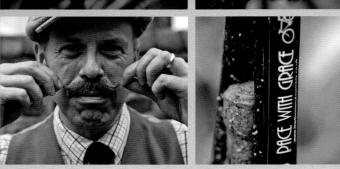
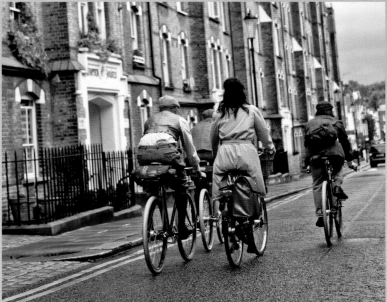

# pashley guv'nors

The Guvnors' Assembly is a collective of like-minded Pashley Guv'nor appreciators, who arrange year-round cycling activities that usually involve an ale or two along the way. Lycra is discouraged, while tweed is encouraged. As their motto says, 'pace with grace'.

The Pashley Guv'nor is a modern version of a classic 1930s sturdy-framed design, available only in Buckingham Black, and boasting handmade leather grips and a Brooks saddle. Owners often like to customise their bikes with such features as ash mudguards.

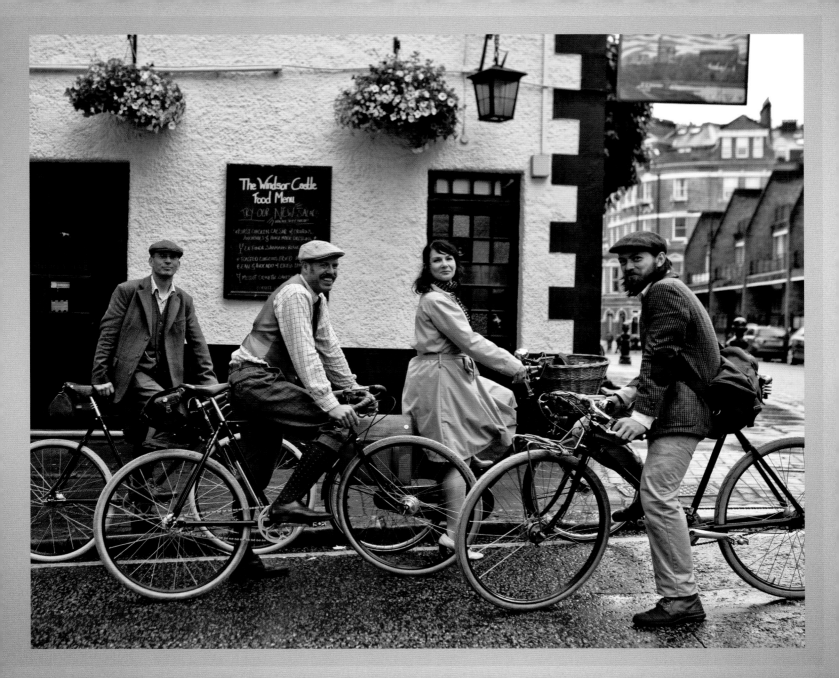

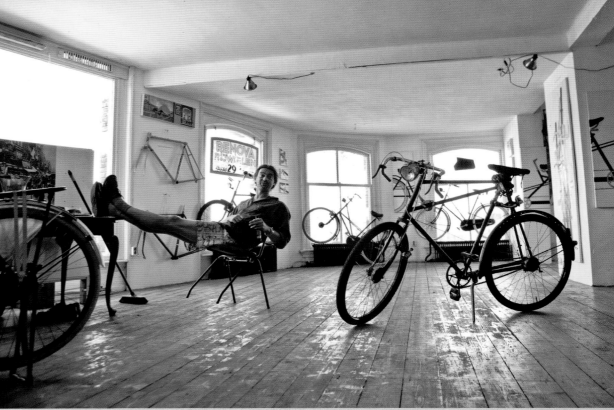

## kwikfiets

'It's true that I'm following in much the same steps as aviation duo the Wright brothers, who coincidentally also ran a cycling repair shop,' explains Willem, the free-spirited owner of Kwikfiets bike shop in Amsterdam. Willem too has the dream of flight. In fact, underground in the shop's basement, well away from prying eyes, is a very early-stage concept. It could easily be treated as a bit of fun. However, his steely-eyed determination shows otherwise.

'Kwikfiets doesn't fit with the stereotypical bike store. We're not really geared to cater for tourists' needs or cycle hire, there's plenty of other places that provide this. Instead we're much more of a free-flowing and relaxed gathering place for bicycle fanatics to express creativity in art, music and views in an off-the-wall style.'

Willem's bike of choice is a vintage Gazelle Mohawk – made by the Royal Dutch Gazelle company, Holland's most famous cycle manufacturer, noted for its unusual frame designs – to which he has added drop handlebars and a few other accessories.

'I'm relatively free of rules; conformity is a restriction and just doesn't fit in with my philosophy of life – you really have to take me and Kwikfiets how you find us. Cycling as I do on my 1935 Mohawk in Amsterdam is far more than culture – it's life.'

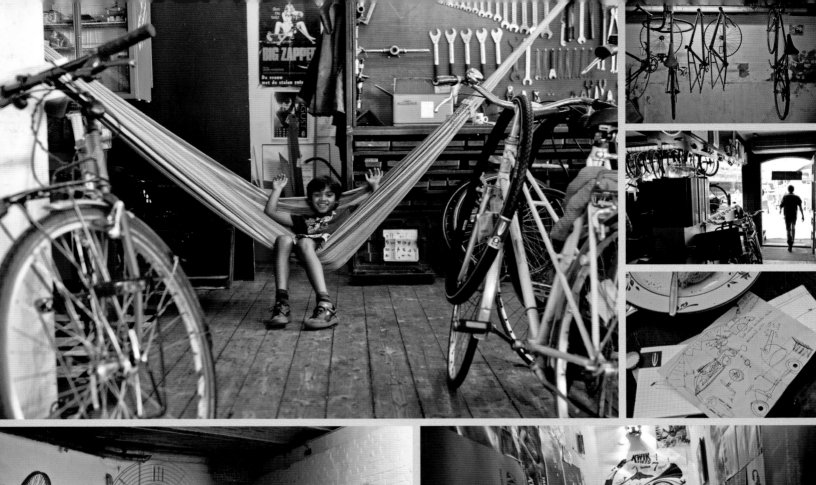
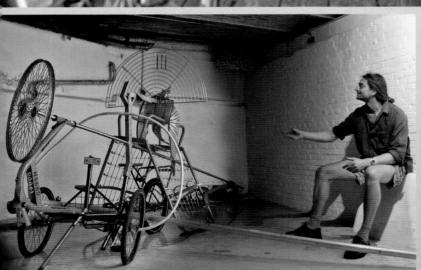

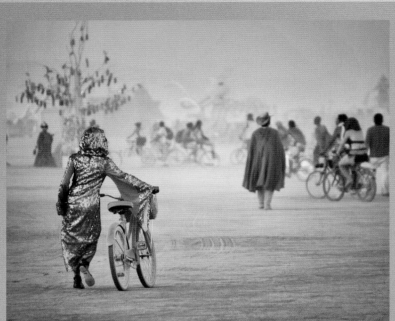

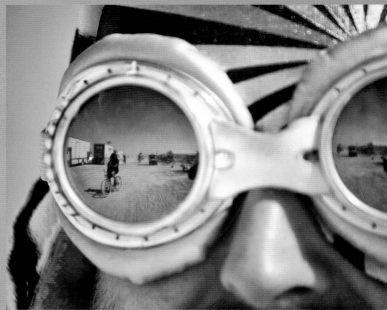

# burning man

Burning Man is an annual art event at Black Rock Desert, Nevada, providing the chance to be part of a week-long temporary and experimental community of over 48,000 people, where a bicycle is not only a crucial means of transportation, but also a form of radical artistic expression, leading to such eccentric innovations as the fish-bike and the bicycle rocket launcher.

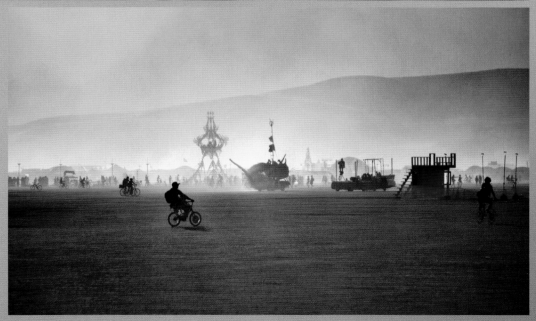

# the bikerist

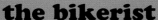

'I make portraits of cyclists who reside in Paris, with the aim of capturing their styles and personal stories. No make-up or styling, people come into the studio dressed as they would on an ordinary day when using their bikes,' explains Jérémy Beaulieu, known as 'The Bikerist'.

'Most of my brilliant ideas come to mind as I cycle,' explains Etaïnn Zwer (shown here), a Parisian freelance copywriter who describes herself as a 'word-catcher' and one of Jérémy's sitters. 'To me riding is all about balance, rhythm and patterns, and it's the same when I write.' She discovered her bike, with its Cinelli handlebars and Mavic wheels, in a junk shop, fell in love with its colour and nicknamed it Leroy after a burlesque character she used to play.

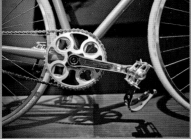

# en selle marcel

Bruno Urvoy is the proprietor of 'En Selle Marcel' in Paris. With a range of cycles from Bianchi to Bromptons, vintage models or a made-to-measure service, along with a beautiful range of accessories, Bruno offers an enticing choice for the discerning cyclist.

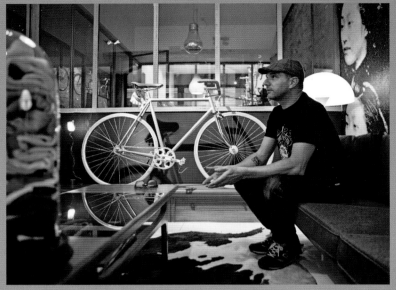

# lock 7

Lock 7 is the first cycle café in London, an inclusive cycle-friendly place to eat, drink, unwind ... and get your bike serviced. It also sells a mixture of newish and old retro bikes in a variety of styles. Founders Kathryn Burgess and Lee King comment, 'Our mission is getting people on bicycles, keeping people on bicycles, having fun with them and making a difference.' The pair, who both worked as forensic crime scene examiners before opening the café, aim to do this by 'removing 'jargon and attitude' from the biking experience.

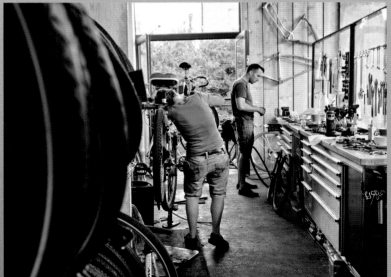

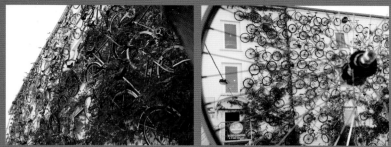

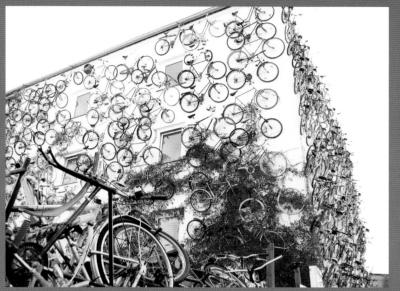

# fahrradhof altlandsberg

Bicycle shop owner Peter Horstmann has bypassed the more traditional approach to advertising by emblazoning his shop's façade with scrap bicycles, adding more whenever a bike reaches the end of its useful life. They currently number over 100.

# exceller bikes

Bruges is a city where the humble bicycle has often been taken for granted, looked on as being strictly utilitarian rather than something with which one can make a style statement. Christian Campers, after a long-standing career in the jewellery industry, set out to change that by following his dream and establishing Exceller Bikes, a cycling boutique specialising in the finest bicycles and accessories.

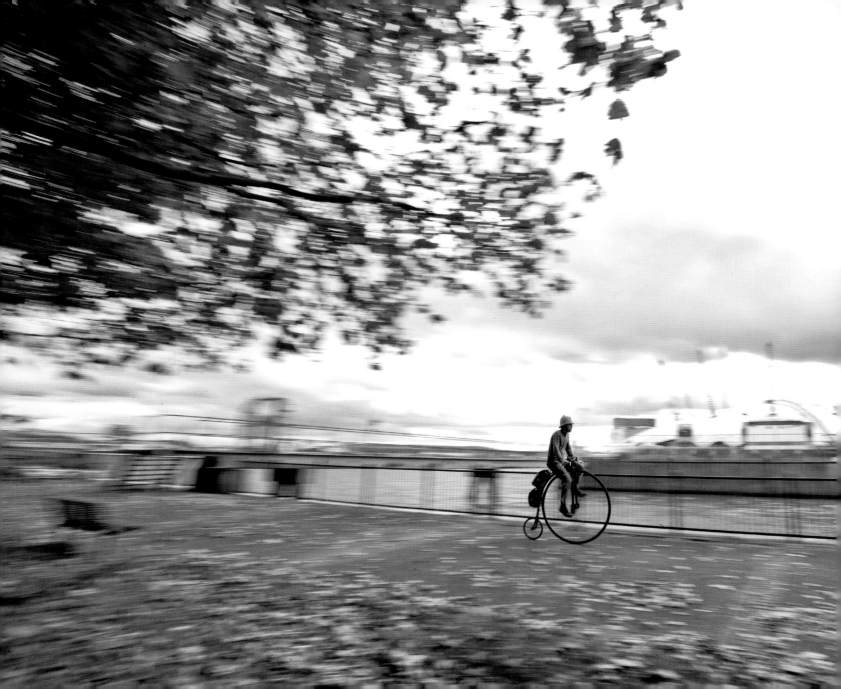

# because i can

'Because I can' is the frequent response I get to the question I often pose after reliving, at first hand, the experiences of those plucky individuals who see challenges as just obstacles to be overcome – 'Why?'

For a majority, once the stabilisers have been removed, cycling will continue to be something they can enjoy throughout life. For some, however, that's never going to be enough to quench their thirst for achievement.

It's difficult to comprehend the magnitude of the challenges, both global and sporting, that the cyclists within this chapter have undertaken and conquered. An Olympian from an era that lacked the technological and commercial advantages of his modern counterparts strove to succeed through the only way he knew...sheer determination. There's a modern-day adventurer who took on the world and emerged victorious, a long-distance cyclist who scaled new heights of achievement on a bike that raised bewildered eyebrows from all he encountered on his journey around the globe, and a Tuscan randonneur reliving a cherished era of cycling.

From future champions paving the way to sporting excellence at an historic velodrome that was once the home of Olympic success, to present-day examples of sporting pastimes, this chapter will introduce you to individuals who, in their own unique way, have pushed the boundaries of cycling far beyond the norm. Those of us without these yearnings can just sit back in the comfort of our armchair and admire them from afar. However, we can dream and, possibly one day, embark upon our own 'because I can' moment.

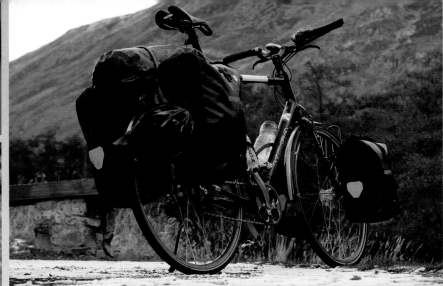

# the man who cycled the world

'Three cycle computers, GPS, witness logs, photographs and 300 extra miles to ensure I had cast-iron evidence of route and distance to satisfy the Guinness World Record adjudicators,' explains Mark Beaumont, who on 5 August 2007 started an epic adventure pushing mind, body and bike to the limit. The adventure: one of the world's greatest endurance records, to circumnavigate the globe by bike. The goal: to shave 80 days off the current record of 276 days.

'At the age of 12, with the support of my family, I rode coast to coast across Scotland. At 15 I made a solo ride from John o'Groats to Land's End. More long-distance rides and university followed, along with a nagging itch for a big trip... around the world!'

In itself cycling the world is no mean feat. Doing it in record-breaking time, when the clock is against you and without the luxury of carefree days to recuperate or a chance to leisurely take in the surroundings, is a feat to be admired. To most, this mammoth challenge would never get further than a casual thought, but for Mark it was the fulfilment of a three-year dream.

While bike durability is of key importance, body maintenance is crucial – energy in = energy out. A team of sports scientists from Glasgow University calculated that in order for Mark to maintain a daily 100-mile routine he would need to consume about 6000 calories per day. The bike chosen to accompany Mark was a signature edition Koga Miyata with a dirt-resistant Rohloff internal gearing hub; a tailor-made bike, light and comfortable enough to get him round the world – and the preferred option of many long-distance cyclists. In five pannier bags he could carry 25kg of carefully packed gear, including camping equipment, tools and cameras. With all the preparations made, he set off with steely-eyed determination from Paris.

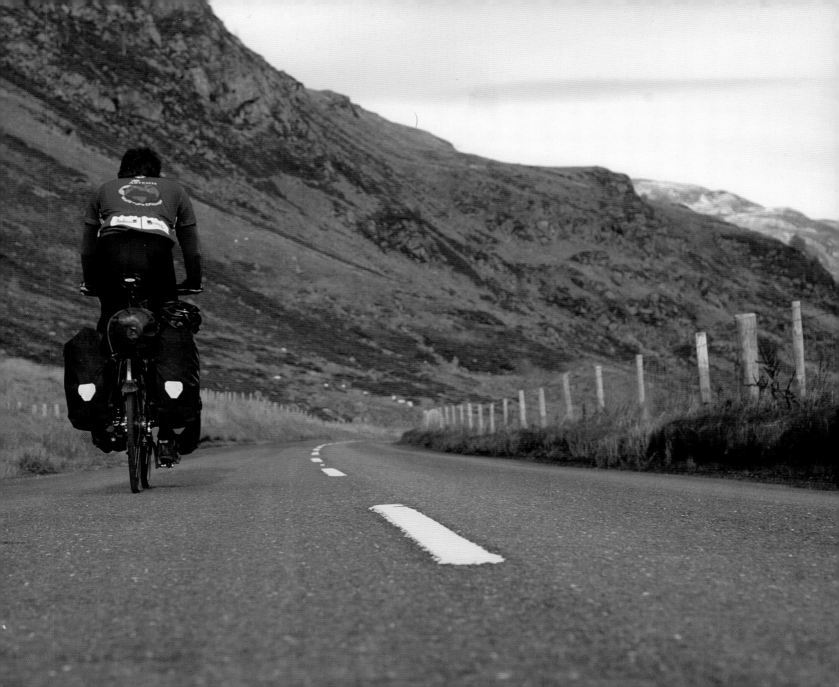

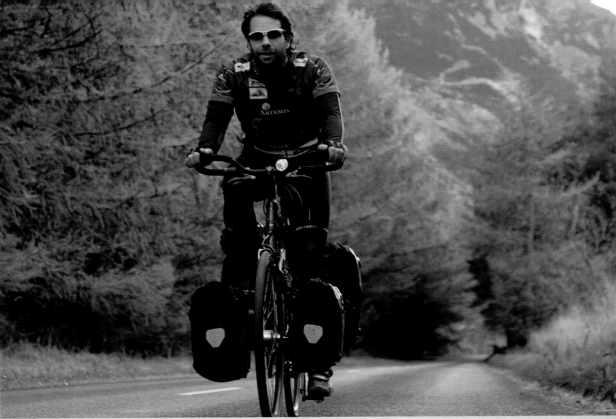

'You might expect the preceding moments, when cycling away and bidding farewell to family and friends (who by now are in tears) to be tough. But after months of planning and a seven-month journey ahead of you the adrenaline kicks in – there's nothing in your mind other than to get going! Only 10 miles into my epic journey the months of training, emotion and lack of sleep caught up with me – my eyes and body started shutting down. Remedy: a strong French espresso from a road-side café.'

Leg one: Paris to Istanbul. 2,200 miles in 22 days. 'My early concerns were physical survival, as with any long-distance journey your mind must be clear of distractions. Three punctures and two broken spokes in nine days! My thoughts shifted to whether the bike would survive.' Leg two: 5,500 carefully planned miles through Turkey, Iran, Pakistan and India. 'The dangerous and difficult section. Police escorts in troublesome areas. Spending nights in police cells for my own safety. Sandstorms and Ramadan – tough for a vegetarian in need of constant calories. Road signs, neither in English nor using the English alphabet, pushes map reading into a whole different league, when the only way to proceed was by matching symbols on maps to road signs.' Leg three: Thailand, Malaysia and Singapore. 'Keeping to 100 miles a day was imperative, any less adds up to days if not weeks of delay.' Leg four: Australia. Freemantle to Brisbane. 'Endless straight roads and vicious headwinds.' Leg five: New Zealand. Dunedin to Auckland. '14,000 miles completed

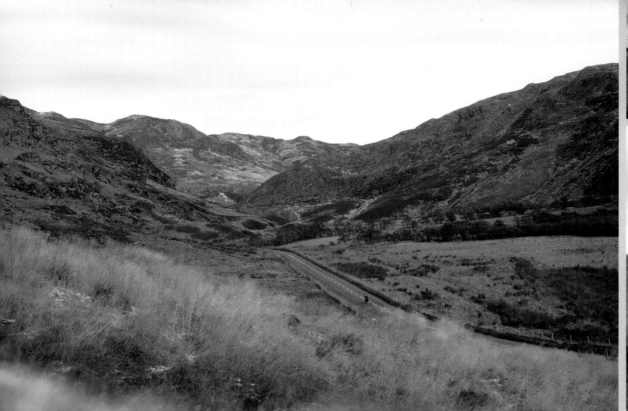

so far.' Leg six: San Francisco to Florida. 'What I initially thought was the easy stretch. However, with busier roads a different dynamic ensued. In Louisiana a car jumped a red light, sending me over the bonnet. The bike survived, but I was shaken up. An uninformed decision to check in to a motel in the wrong part of town led to me being mugged and threatened – after 16,000 relatively danger-free miles it was the last place on earth I expected this to happen.' Leg seven: Lisbon to Paris. 'With America behind me, my mind focused on the finish line (even though it was 1200 miles away), giving me a physiological boost – enough for a sprint finish from Lisbon to Paris.'

As Mark crossed the finish line at the Arc de Triomphe, with a blue-light police escort, the enormity of his achievement hit home. He had fulfilled his dream of becoming the fastest round-the-world cyclist in history. In all, he'd knocked a massive 82 days off the existing record after having spent 1500 hours on the saddle, pedalling 18,297 miles in 194 days and 17 hours!

'I proudly held the record for two-and-a-half years. I'm lucky, as some subsequent record attempts have not been recognised due to a lack of miles or uncorroborated route. Now you can see why I went to the lengths of proof that I did.' Imagine having a phone call: 'Sorry you didn't qualify for the record attempt, better luck next time.'

In Mark's own words: 'Hey, it's not easy, the dream's hard...but it's nice.'

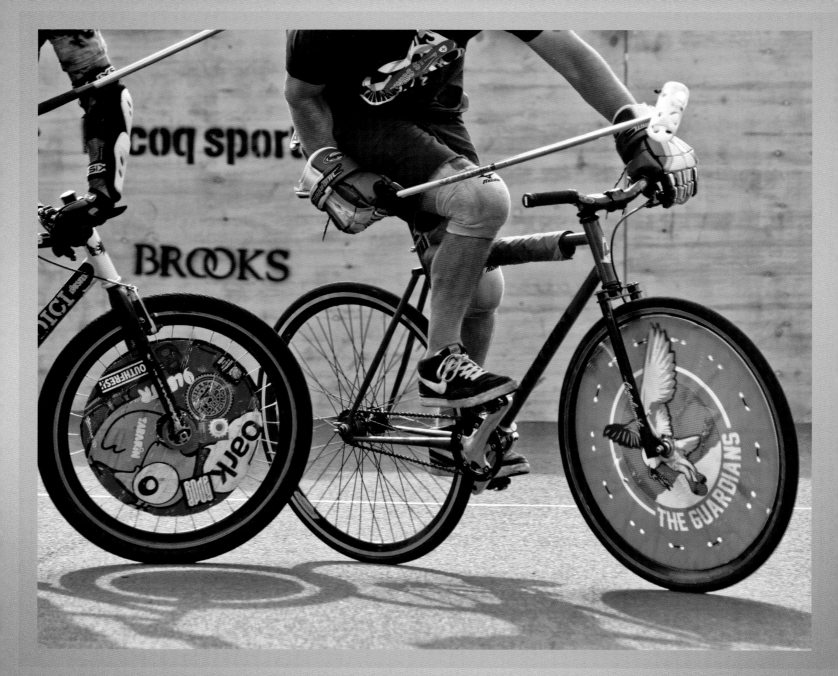

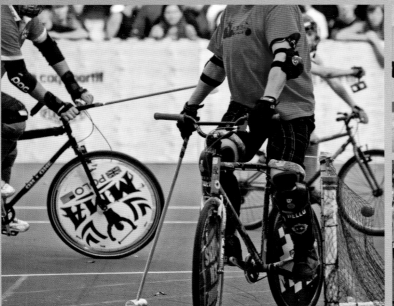

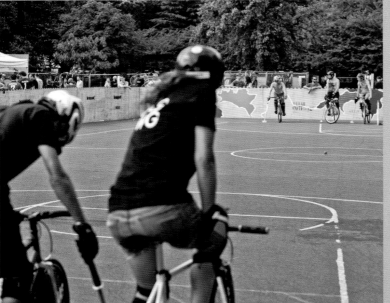

# bike polo

The London Hardcourt Bike Polo Association (LHBPA) was formed to encourage, support and develop participation in this rough and tough sport throughout London. The London Open tournament is now a firmly established fixture on the bike polo calendar. It hosts in excess of 80 teams from more than 15 countries and men's, women's and mixed teams compete. Any bike can be used as long as it has at least one braking mechanism (a fixed-gear drive train with foot retention is deemed acceptable) and has no sharp edges or other unsafe parts. It also must not have any modifications designed to block the ball.

'I was born in Bridgeport, Connecticut, in 1920 to British parents. They were happy times until the 1928–32 depression forced us to return home to England. My father, Charlie, a keen sportsman, continuously pushed me – vicariously living out his life through me in order to satisfy his sporting dreams,' explains Tommy Godwin, double bronze-medal-winning cyclist in the 1948 Olympics.

'At 14 I left school and after a short while became a grocer's errand boy. Cycling, fully laden, 15 miles a day kept me fit and my interest in cycling grew – spurred on by reading sports reports from the 1936 Olympics. A sports day between rival grocers was my early cycling triumph. Not having a bike of my own, I borrowed one and with only a day to practise took the bike out for a sprint. Unaccustomed to fixed-gear bikes, I took a dive over the handlebars. Though still nursing wounds I managed to compete and come third, receiving a small stopwatch, which my father then used for my competitive timings.

'Long hours at the grocer's restricted my cycling, so I started work at the BSA factory, which incidentally also had a sports day. I duly entered, but the race didn't go well due partly to my inadequate bike. However, seeing potential my father remarked, "Do as I say for a few months and I'll buy you a racing bike." That he did; no small gesture considering the bike cost the equivalent of two weeks' wages. It was then full-on training to get ready for the following year's BSA race. My father wanted me to make a clean sweep of the board, which I did – winning everything I entered.'

## the olympian

Tommy's new fixed-gear bike was as lightweight as it could be for the time, though obviously it bears no comparison to today's modern cycles. He was invited to trial for the 1940 Olympics

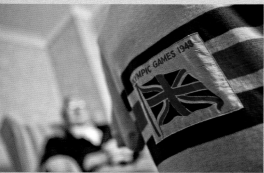

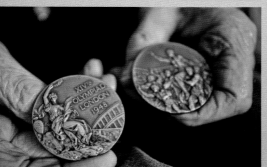

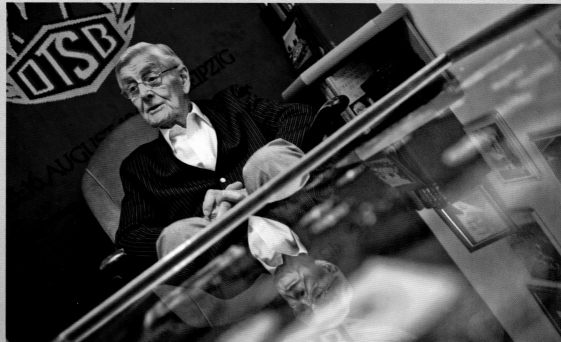

and won the BSA 1000m time trial in 1939. Sadly, the start of the Second World War meant the cancellation of the Games.

'The BSA factory was important to the war effort (BSA was actually the Birmingham Small Arms company, which had diversified into bicycle manufacture towards the end of the 19th century), so I was never called up. I continued to cycle through the war years, during which time I met and married my wife, Eileen – much to my father's outcry, deeming it the end of my sporting career. At amateur level I continued competing successfully, never receiving prize money, just medals and countless carriage clocks and canteens of cutlery.

'The 1948 London Olympics (the 'austerity' Games) was announced in 1946. I entered the trials and was picked just weeks prior to the Games starting. With my BSA bike, which I have to this day – and fuelled by Mother's spam fritters – I won bronze in both the individual 1000m time trial and 4000m team pursuit at Herne Hill Velodrome.

'Upon my winning the individual bronze my father fell to his knees in tears of joy. A level of pride not easy to put into words – his reaction still brings tears to my eyes even now.

'Monday morning and back to work. No hero's welcome, just "Well done, you've won a medal, now get working." At the age of 91 I can look back and feel proud of my achievements. Since the end of my sporting career I've done whatever I can to give back to the sport I love. I was honoured to be an Olympic Ambassador at the London 2012 Olympics and took part in the Olympic torch relay. Now, if I ever feel down, I look at my medals, cast my mind back and relive wonderful memories. I've so much enthusiasm for life, every time I speak, I speak from the heart – I love people, I love life...I've had a wonderful life.'

Just as I neared completion of this book I learned the sad news that Tommy Godwin had died. It was a privilege to have met Tommy – a true gent. He chatted to us for several wonderful hours and his life story kept us enthralled, while his bounty of medals and trophies left us in awe.

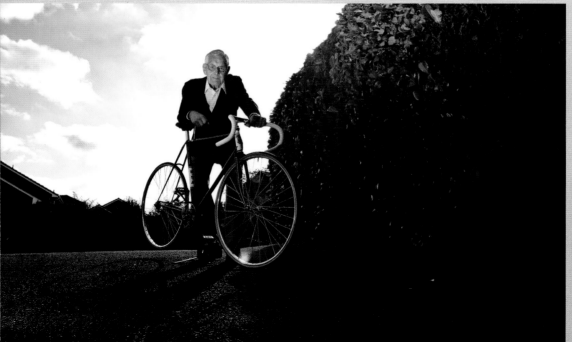

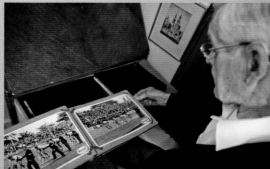

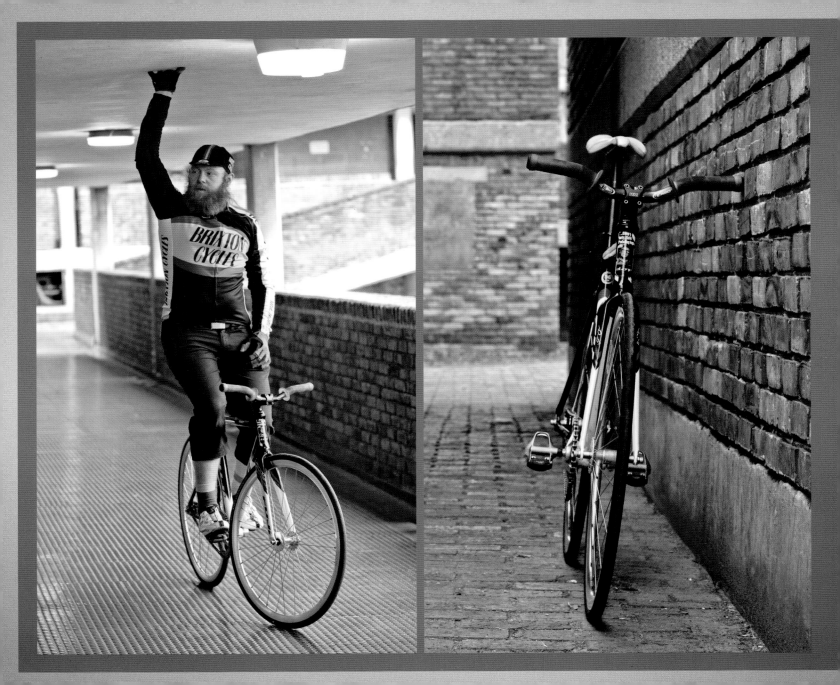

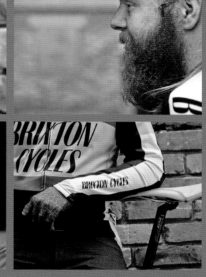

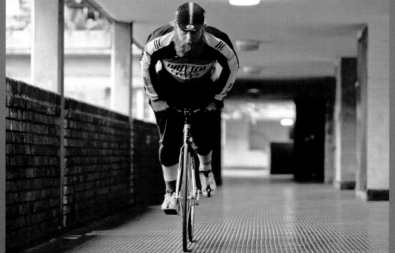

# hillbilly

'I'm pretty distinctive, so a lot of people recognise me riding around London,' says Jim Sullivan, aka 'Hillbilly' as he's now affectionately known after a downhill mountain bike race turned sour and relieved Jim of his two front incisors. 'I've also had the privilege of being the record holder at London's eccentric IG Nocturne bicycle extravaganza. It was for the longest fixed-gear rear wheel skid – an impressive, if I say so myself, 107 metres!'

The Nocturne is an annual night-time cycle event held at London's Smithfield Market, where races include penny-farthing and folding-bike classes as well as elite races. Jim has upgraded the cranks, wheels and handlebars – cut-down MTB riser bars – on his 2008 Fuji Track Pro to make this light, agile bike just right for carrying out his trademark skids.

After taking a childhood activity to a whole new level, Jim has now mellowed and become heavily involved in track racing at Herne Hill Velodrome. His extensive collection of cycles is, he says, 'what you get for working in bike shops your whole life'.

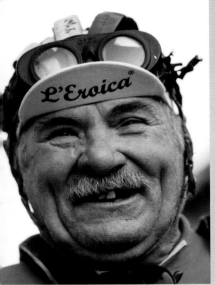

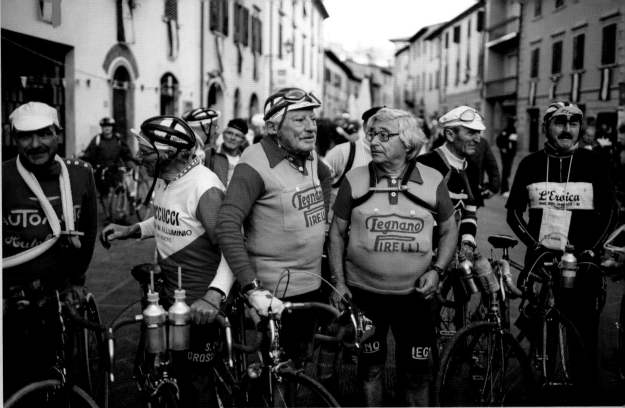

# l'eroica

Every year since 1997, thousands of cyclists from all over the world have descended on Tuscany to take part in an event steeped in sentimentality, an event from an era when such things as carbon-fibre bikes were the crazy talk of the future. L'Eroica is recognised as one of the greatest amateur cycling events in the world. It provides a unique day's cycling in an atmosphere quite unlike any other. The only prerequisite is that all those who enter must be riding a bike from a year preceding 1978.

Four routes are available, allowing for varying levels of ability, from the longest at 205km with a 5am start time, down to a seemingly more leisurely 38km. At least it

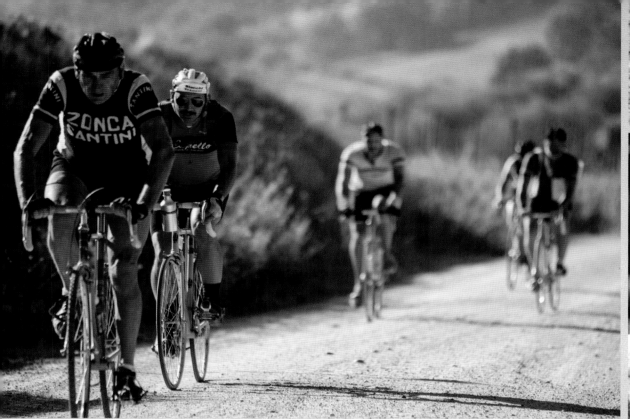

would be, were it not for the bolt- and joint-loosening ragged road surfaces – which require nerves of steel when on a steep descent. Even experienced cyclists have been bested by this randonneur, proclaiming, 'It's not for me!'

However, this is part of the event's charm. It's easy to see why there is no shortage of colourful old-school woollen cycling jersey participants signing up, when riders find themselves winding through the stunningly beautiful undulating vineyard and olive tree-lined roads of Tuscany. The dusty heat-hazed byways are not yet spoiled by Tarmac, box junctions and white lines. And if that isn't enough, the chance to savour the fine food and wine of Italy should have you dashing to your nearest vintage bike shop.

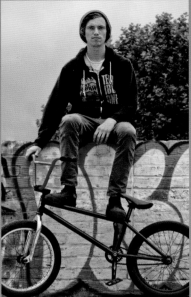

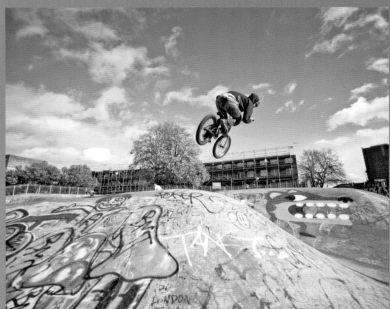

# brixton billy

'There's a lot of negative misconceptions about BMX riders...most are untrue. On the whole we're a good bunch. So much so that an unwritten code of conduct exists between us to look out for each other and lend a helping hand, or offer a sofa for the night if the need arises. We're a tight-knit community based on instant trust between fellow riders – trust that mustn't be abused,' explains Brixton Billy. 'BMXing has enabled me to travel a lot when seeking new places to ride – whether it's an urban playground or purpose-built skatepark. I've touched down in most of Europe with nothing more than passport, bike and a change of clothes – and I've always found somewhere to stay.

Billy rides a custom-built model nowadays that is light years away from his early bikes – 'lighter and more stable' – sourcing the frame, forks and bars from the specialist rider-owned S&M Bikes in the US. 'I started working at Brixton Cycles when I was 17. It's the ideal job for me, as Stockwell Skatepark is right next to the shop – a place for any self-respecting BMXer to visit when in London. BMX riding means you've got to push yourself. That's the kick I get out of it – taking a risk and hoping it pays off. It doesn't always, but you learn from experience and have to get yourself back on the bike as soon as the body allows.'

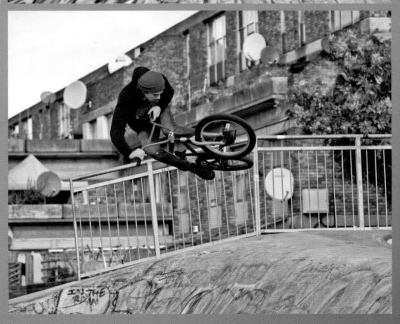

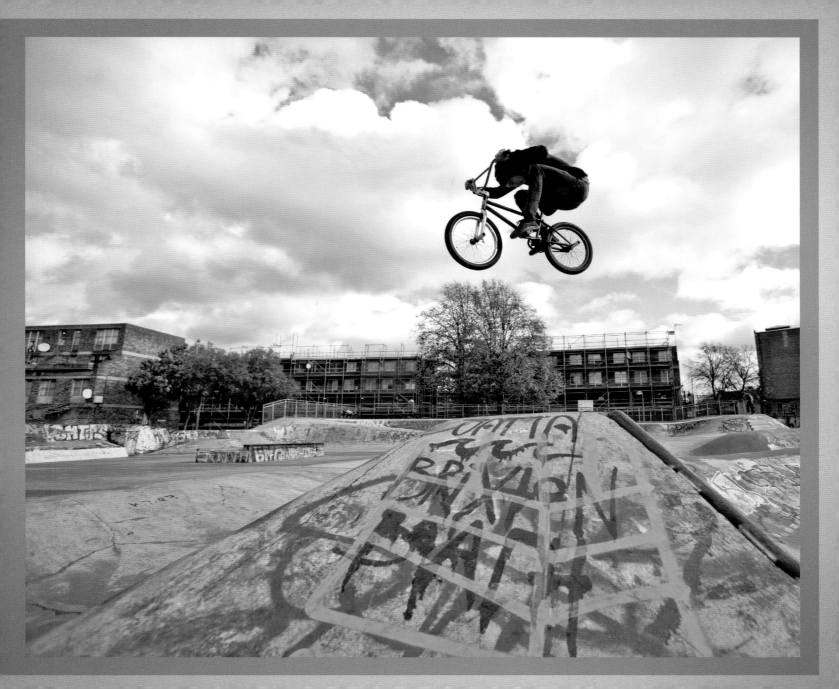

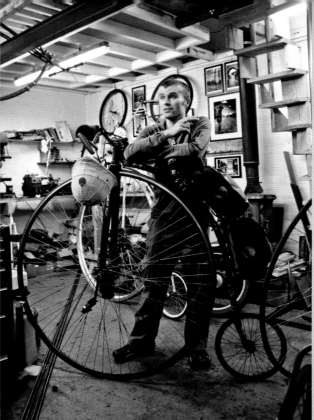

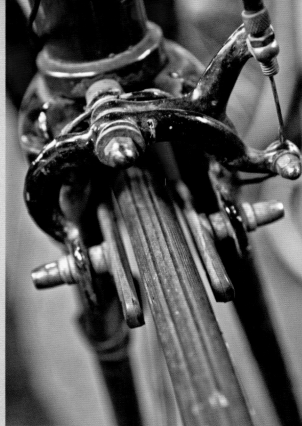

# penny-farthing world tour

'It wasn't a vain attempt for a free drink with "I'm off round the world!" It was a well-thought-out, planned endeavour. In 1998 I rode to Amsterdam on my trusty pre-war BSA. Early on it was clear that riding a bike was the only way to experience a country. Henceforth I planned to circumnavigate the world like Thomas Stevens in 1884 by penny-farthing – yes, penny-farthing,' explains Joff Summerfield.

'I built my first Mk-1 penny-farthing in 1999. However, soon afterwards an altercation with a car crumpled the front wheel. With a new wheel, and to celebrate the millennium, I rode to Paris, learning a valuable lesson along the way – namely the Mk-1 was too heavy. The Mk-2 followed in 2000 along with a Land's End to John o'Groats test run. In 2001 I found near-perfection with the Mk-3 – I was ready for the trip of a lifetime. Off I went, with friends and family bidding me a fond farewell. They didn't plan for me to be home for tea, but that's what happened, when after 26 miles my knee gave out. It was 2003 before both knee and Mk-4 penny were ready. This time I made it further – Budapest – before another knee injury. Surgery and a few spectacular head-over-handlebar incidents held me up again.

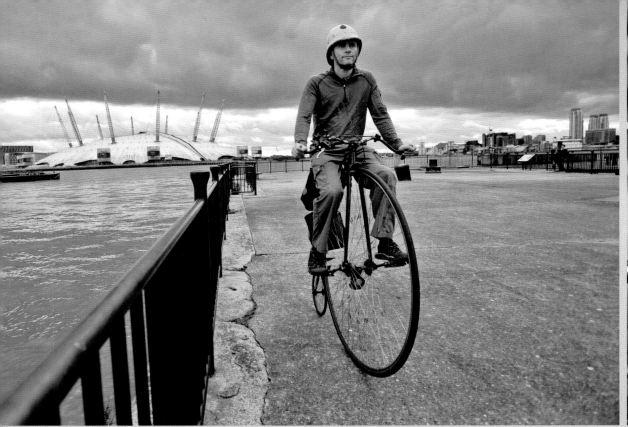

'By now, friends and family had been getting used to my regular goodbyes. So my departure in May 2006 was greeted with comments of "Yeah, see you soon!" In November 2008, after 30 months, 24 countries and 22,500 miles, I returned home triumphant.

'The Great Wall of China, foothills of Everest, Death Valley Arizona and countless border crossings – they were all fun in their own right. Seeing a far-off glint from a border guard's binoculars left me wondering quite what they thought, especially when a pith-helmeted individual aloft a large wheel rode into view – I was never greeted with anything but bewilderment.

'As the bond with my bike grew I started referring to it as "my wife". At nights I never contemplated letting the bike out of my sight, even if that meant lugging the unwieldy wife up countless flights of hotel stairs.

'A journey and achievement like mine changes your state of mind. You become more tolerant, appreciative and don't take things for granted. You can also feel rather lost when the challenge is over – what do I do next? Having said that, I want to do it again. There's lots of things yet to be seen and you will never run out of places to visit.'

# herne hill velodrome

Home to cycling during the 1948 London Olympics, and dating back to 1891, Herne Hill Velodrome has undergone many changes over the years, including the original wooden slatted surface being replaced first by concrete and, most recently, by a state-of-the-art all-weather surface. Powered by volunteers, it hosts more open race events than any other velodrome in the country, and is a favourite haunt of Tour de France and Olympic champion Sir Bradley Wiggins.

Beginner sessions are offered where anyone can hire a special bike and have a go on the famous track. With the help of the Herne Hill Velodrome Trust its future seems secure, and it will continue to be used by Olympic hopefuls for a long time to come.

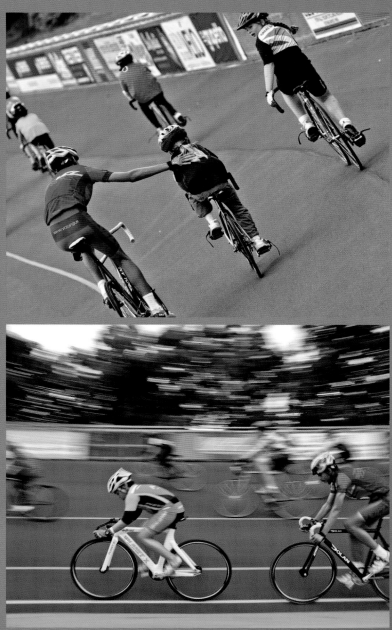

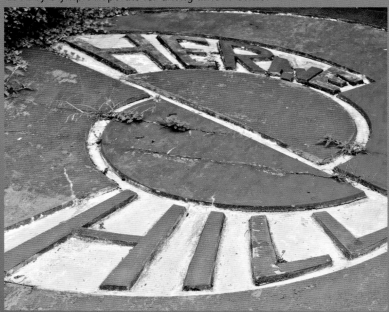

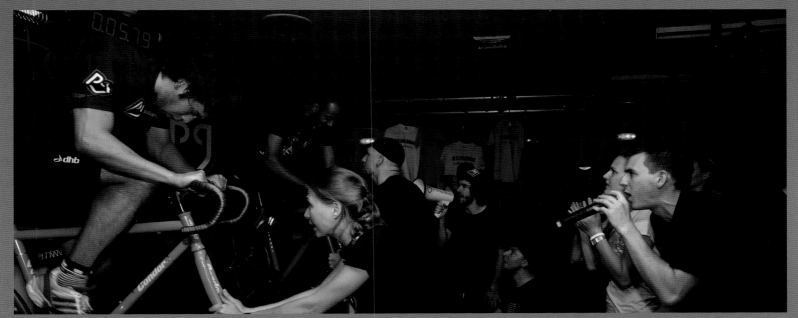

# rollapaluza

Rollapaluza. Ingredients: two participants and a pair of custom-made rollers connected to a huge dial. Objective: a cycling battle over a simulated 500m distance with split-second digital timing and speeds of over 50mph. Goal: be the fastest. All done to accompanying music, motivating MC and cheering crowds.

Rollapaluza Roller Racing started in 2000 after a cycle courier saw a roller race at the 1999 Zurich Cycle Courier World Championships and was inspired to arrange a similar event in London. This ran annually and gained a growing reputation among the burgeoning underground fixie scene. In 2007 Caspar Hughes (a colleague of the courier who had originally brought the concept back to London) and Paul Churchill launched Rollapaluza as a commercial enterprise; they now have franchises in three countries, with 20,000 participants in the UK in 2012.

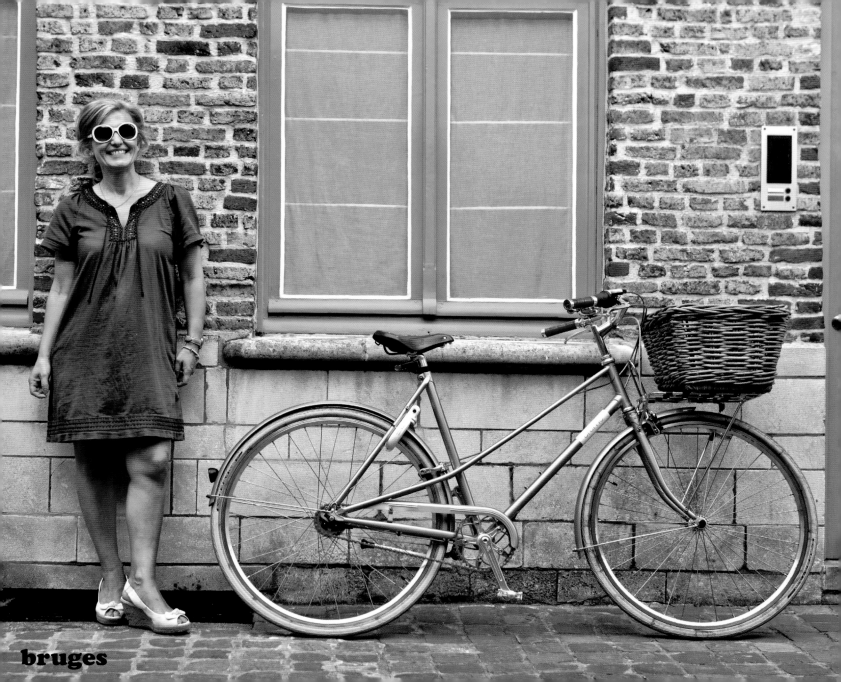

bruges

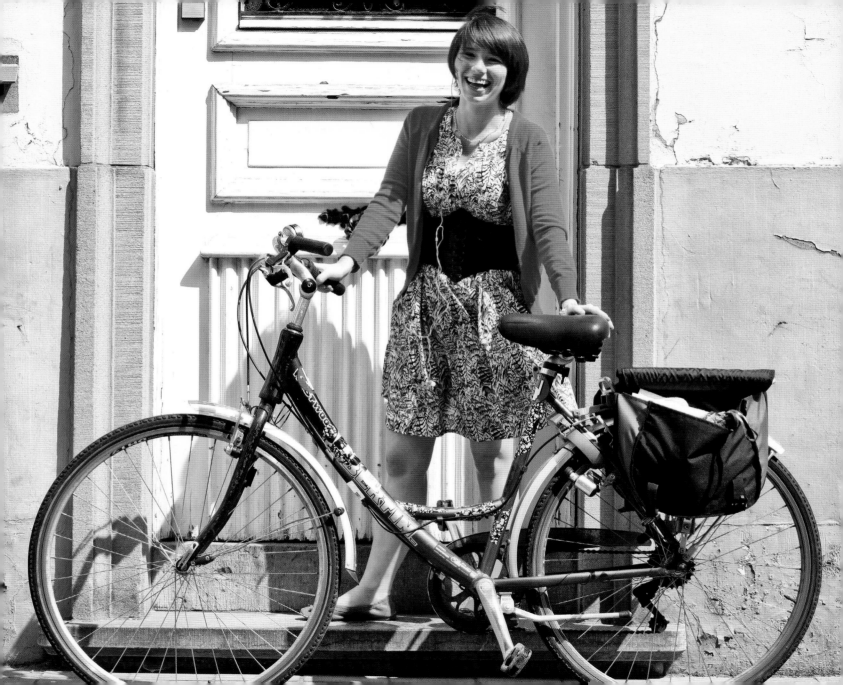

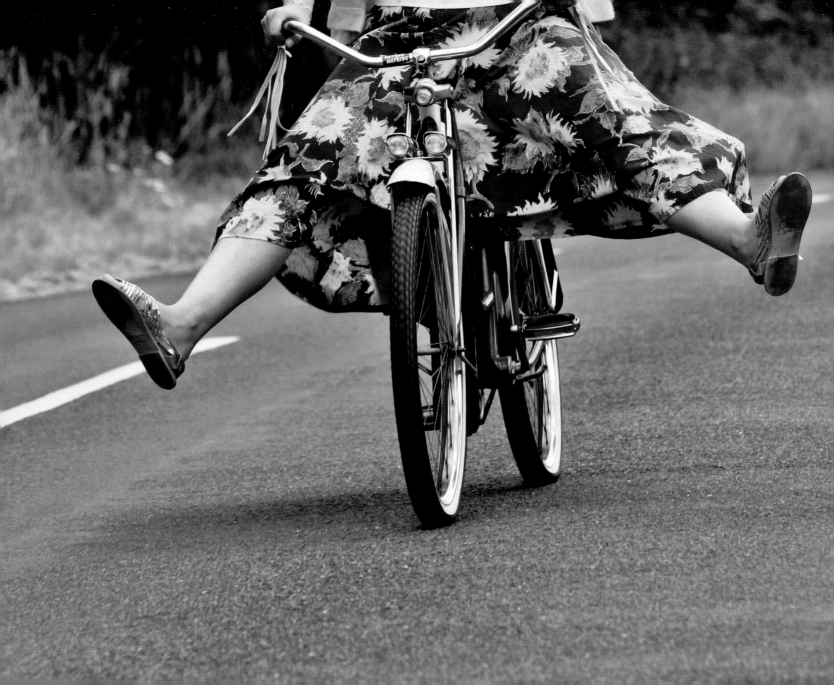

# the mavericks

Since its conception, the bicycle has been an invention that has evolved at its own sedate pace and not through a forced necessity. Within this chapter you will encounter cyclists who are comfortable to go it alone and don't see the necessity to conform to stereotypes. For them, the bike is a form of design so effortlessly simple that it's an ideal tool for creative embellishment – an extension, for instance, of their love of vintage fashion or appreciation for design, art and inventiveness.

Individuals such as Elizabeth have gone to extraordinary lengths to obtain a much loved bike. There are forward-thinkers like Tom Karen, a leading industrial designer who sketched a bike that's engraved with umpteen childhood memories. For DJ Norman Jay, the realisation of a youthful dream was fulfilled much later in life, but it meant no less to him for that. Further afield, in Brooklyn we find a collector who goes to the nth degree in search of the perfect bicycle and accoutrements, while Toon is a Dutch inventor whose creations are limited only by his imagination – he's a true master of bicycle eccentricity. Cally has acquired an abundance of cherished bicycles and an appreciation for cycling that has led to an unusual addition to his bucket list. Finally, we see evidence that fashion icon Sir Paul Smith's insatiable enthusiasm for cycling is on a par with that of his passion for stylish attire.

Future generations will continue to explore the diverse avenues of cycle culture; perhaps some will be inspired by these pioneering mavericks and their contagious enthusiasm for cycling. Their ardent inventiveness proves that being different is good...very good.

MICHELIN TYRES

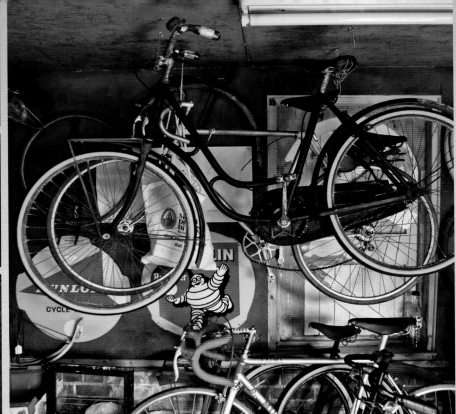

# cally

'My bicycle collection shouldn't be considered a museum. Those sort of collections seldom get touched, let alone used and appreciated. Everything I possess is used, otherwise what's the point in owning them? Maybe they're not used as regularly as I would like, but at least once a year all the bikes get a good outing, including my updated re-creation of Lawson's Bicyclette of 1879 (pictured right), made by myself and my good friend,' explains cycling aficionado Cally Callomon. A lengthy, successful but stressful career in the music industry (managing high-profile artists and art directing) led Cally to adjust career priorities, enabling him to fund a more leisurely habit of cycling.

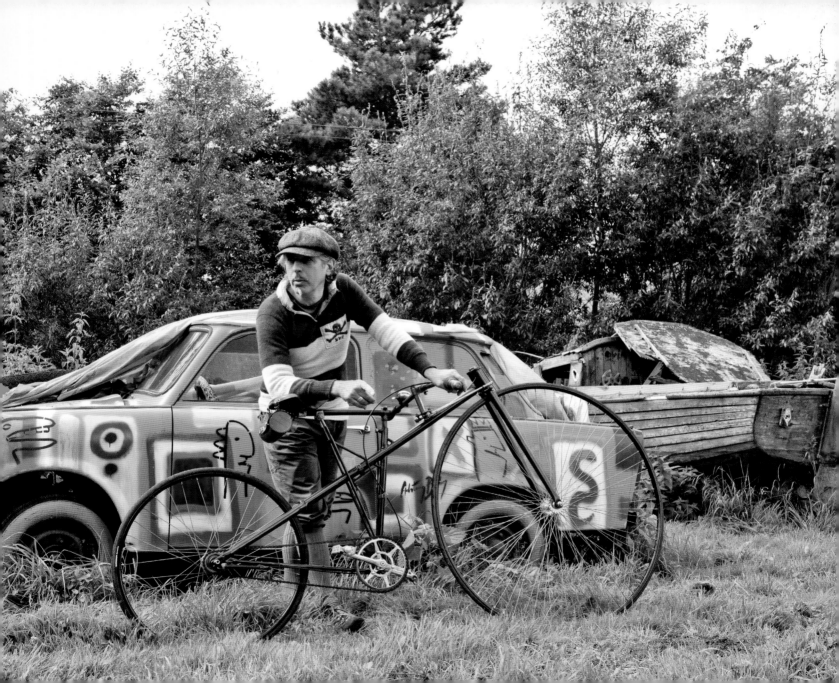

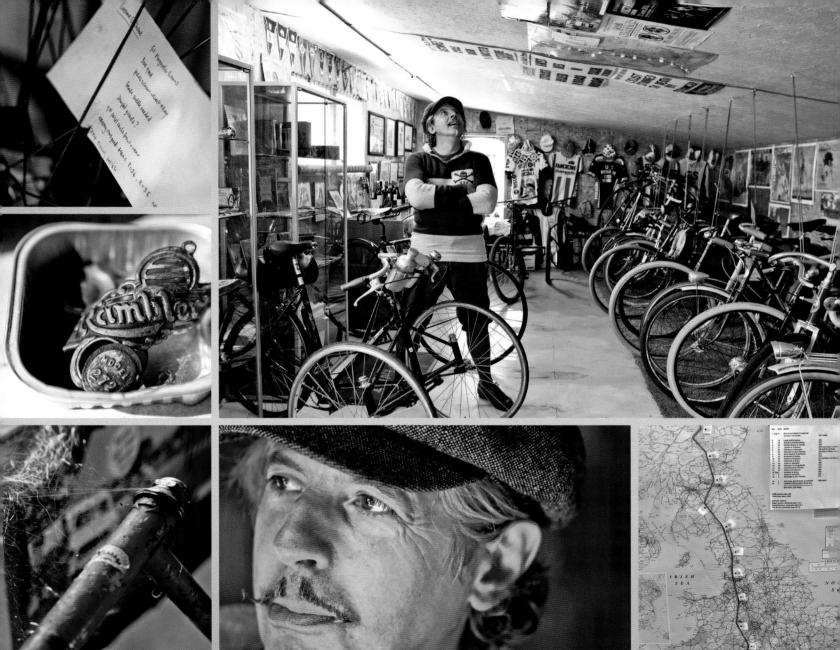

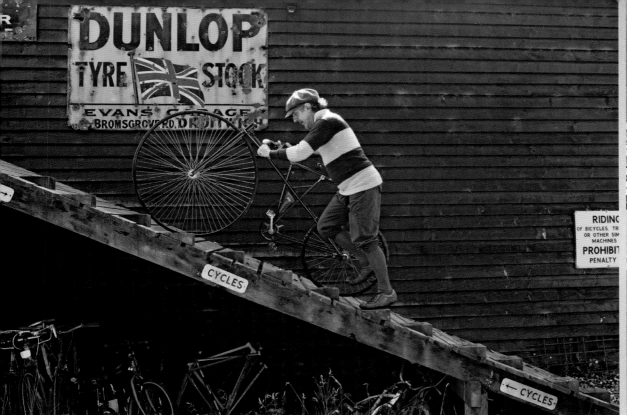

'Each and every bicycle I own has a place and a reason for being in my collection. Before a ride I choose a bike depending on my mood. That's what inevitably happens with cycling, you build a relationship with a bike and you know from previous experience how it will make you feel when you set off.

I'm fortunate enough to live in beautiful Suffolk, nearly slap-bang in the middle of sheet No. 155 on the Ordnance Survey map. My plan, before I'm plucked from this world to meet my maker, is to have cycled every road on the OS map within an 11-mile radius of my village – I'm collecting roads, if you like! There's no scientifically planned route in order to complete the task with the least miles – far from it. On occasions I've found myself cycling 30 miles along previously charted roads just to ride half a mile on a road I've not yet marked off!'

Tom Karen is a prominent industrial designer but perhaps not a household name outside his professional circle. However, chances are that Tom's design magic has worked its way into many a household – from washing machines and the Marble Run (every child's favourite) to radios and cars, including the Bond Bug and Reliant Scimitar GTE. However, the one item he feels most proud of is the Raleigh Chopper, a bike that could make even the naughtiest juvenile succumb to parental bribery – 'Be good and you can have one!' Let's face it, for those of us growing up in the 70s, what wouldn't we have done to secure ownership of the now iconic bike.

'In the early 60s I was managing director and chief designer of Ogle Design. In search of creative fresh thinking, Raleigh commissioned Ogle to submit various concept designs to compete against the Schwinn Krate series.'

Before the Chopper swaggered into town, kids' bikes were just scaled-down versions of something your dad would ride to work. Certainly not anything a self-

## the designer

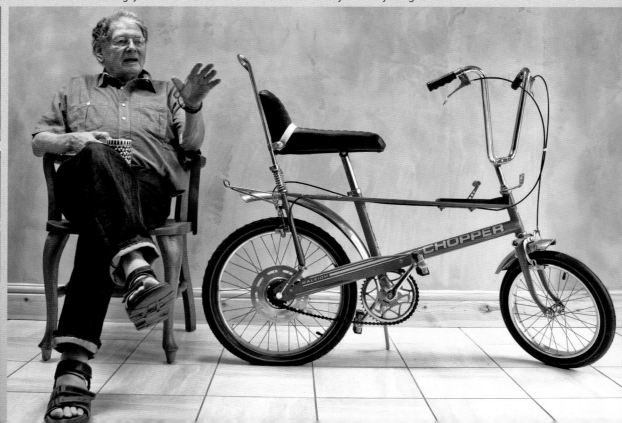

respecting child would choose to be seen on cruising the suburban streets. The Chopper was the epitome of coolness, with its wedge-shaped frame, 'Polo' seat, ape-hanger handlebars, 20/16-inch dragster wheels (easily enabling you to, with a shift of your bum towards the rear of the seat, pull a spectacular wheelie), Sturmey Archer central gear-shift and kaleidoscopic colour schemes.

'Sadly, recent claims on the design concept have arisen. I take nothing away from the skills of the late Alan Oakley, who headed up Raleigh's design department. However, the concept was my idea. It's really not my cup of tea to get into heated arguments about the design – in my mind and on paper, I know what's true.'

The Chopper had a fantastic innings until 1984, when the BMX diverted the attention of the nation's youth. By then 1.5 million had been sold. 'As a designer, for my work to still evoke feelings in others of youthful nostalgia is truly a wonderful thing.'

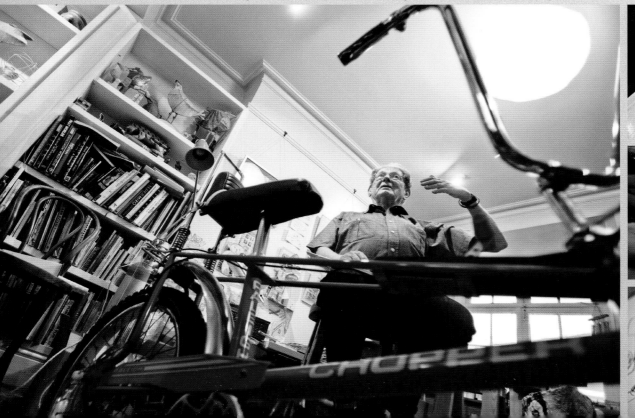

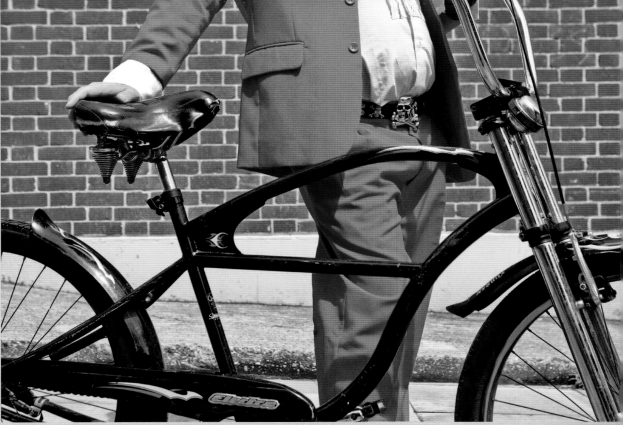

## the urban voodoo machine

'Not so much cycling chic, just our everyday style that so happens to cross over into what we wear when cycling,' explains front man, singer and songwriter Paul-Ronney Angel and snake-charming, fire-breathing, tuba-playing wife Lady Ane Angel from the band The Urban Voodoo Machine. Their music doesn't fit neatly into a traditional genre, so they happily invented their own, namely Bourbon Soaked Gypsy Blues Bop'n'Stroll.

Their bikes are equally eccentric, made by Deuce and customised by the pair with little touches like the skull-air-valve covers. Ane bought hers first in Copenhagen and an envious Paul eventually managed to pick one up in London five years ago, entranced by the laid-back, relaxed style and the comfy ride provided by the large tyres.

'We're both originally from Norway, which has a big cycle culture, especially in the cities like Bergen and Oslo,' says Ane. 'A car isn't really a necessity for us in London. There are far quicker and less stressful options available – namely his and her cruisers. I'm a hair stylist and by choice I cycle to work every day from Hackney to Soho. High heels may not be the most practical choice for cycling – but I wouldn't dream of changing my attire for anyone!'

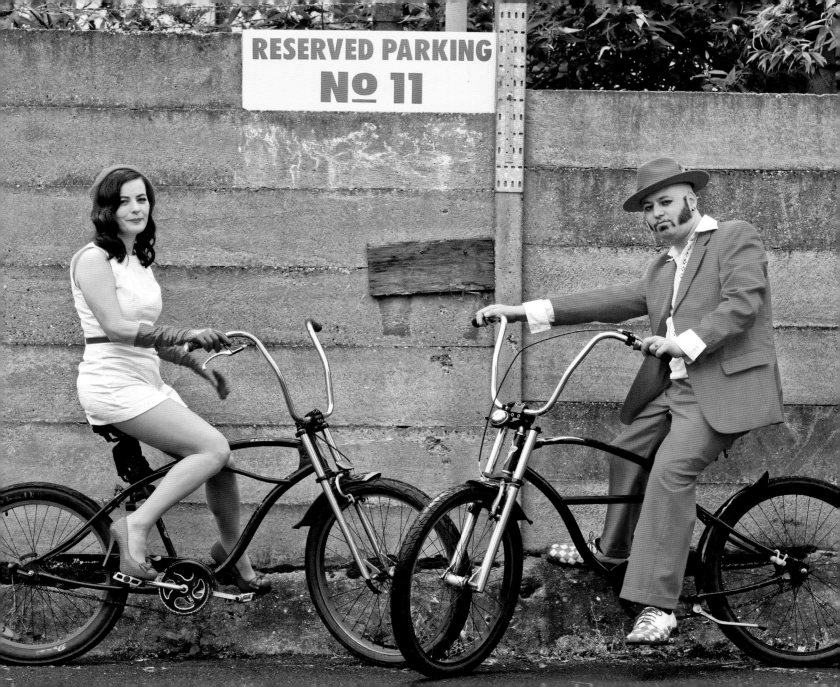

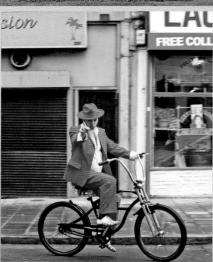

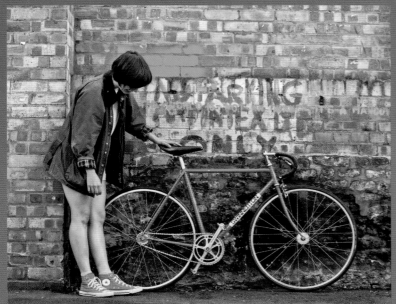

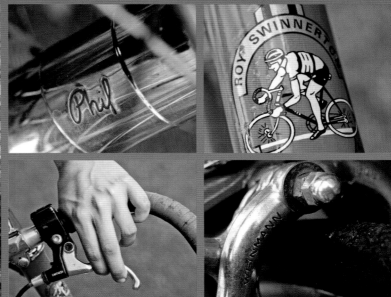

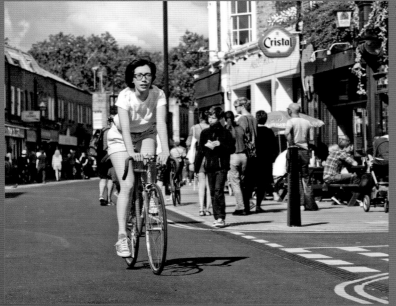

# yasi and roy

'My bike's called Roy – he's my pride and joy,' explains Yasi, a London-based fine art graduate and screen printer. 'Roy's a fixed-gear bike, the third I've owned and second that I've built myself. I spent over a year taking pride in sourcing just the right parts for Roy. He started with a frame, a set of Phil hubs and a Campagnolo Pista chainset, all found on the LFGSS (London fixed-gear and single-speed) website; a great community for fixed riders. The rest of the parts, including a Dirty Harry brake lever (continuing the theme of male names), all came from bike jumbles, which resulted in meeting many vintage bike dealers – one of whom has become a good friend.

'I don't ride a fixed-gear bike for fashion's sake, even though there's a stylish undercurrent in the scene. Instead I ride Roy because I built him myself and, quite honestly, fixed is an easier solution around town. I haven't broken the news to Roy yet, but I've another collectable bike that I'm restoring – it's going to be a struggle dividing my time equally between them both!'

# urban assault kurb krawler

'A few hours in the workshop with an old BMX frame, my own custom-made front steering boom, fat cruiser tyres and a scattering of military-themed accessories, a month of hard graft and, hey presto, my latest creation – the Urban Assault Kurb Krawler,' explains Neil Stanley. 'It's my personal take on a recumbent-style bike from the modern age, called the "Python Lowracer". Although the concept is ridiculous, it actually works! Half the fun for me is in the design and build. In fact, this is the fourth I have built to date. It's a whole different riding experience and difficult to master. Not only do your feet do the pedalling, they also double-up and provide the steering by way of the pivoted centre-steered front end – look, no hands!'

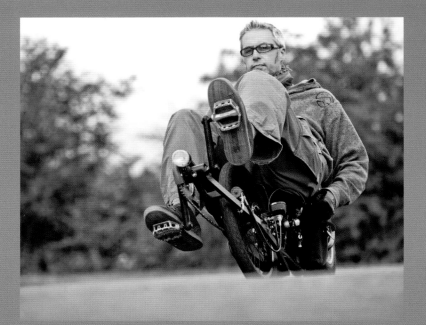

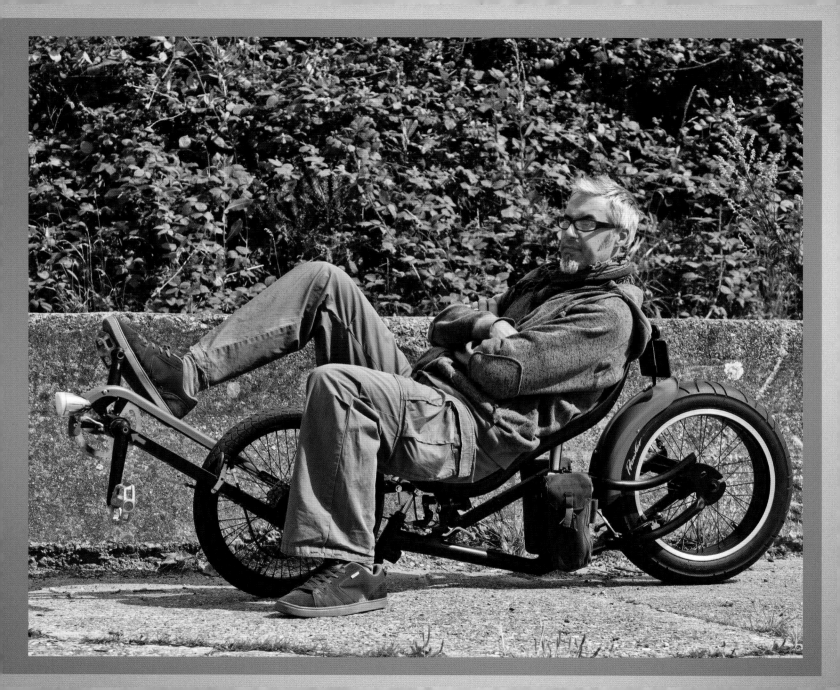

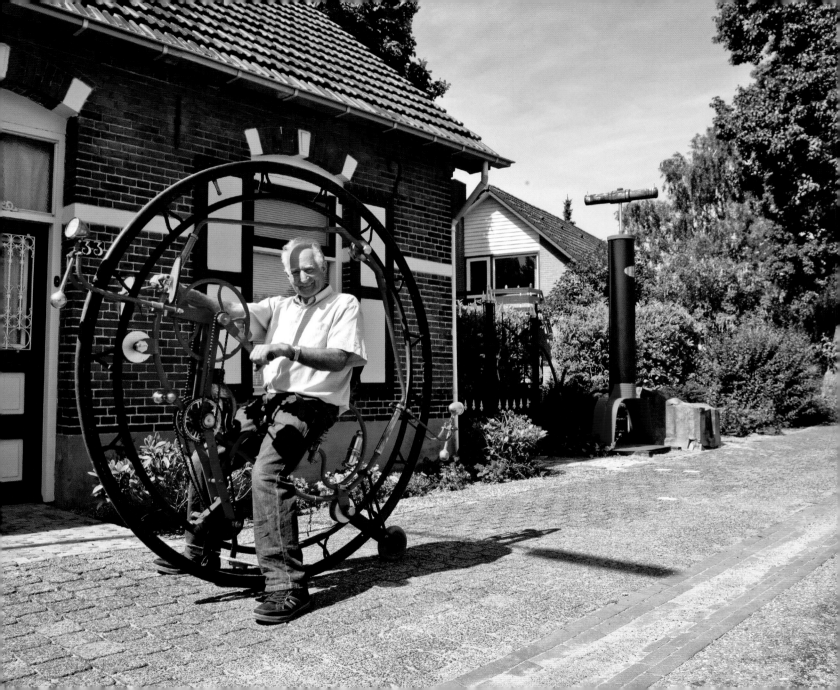

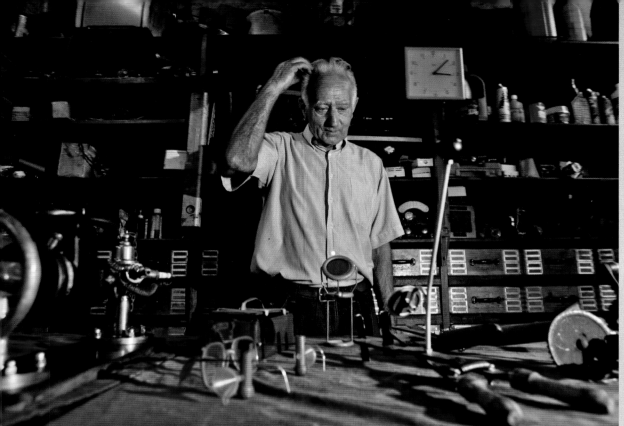

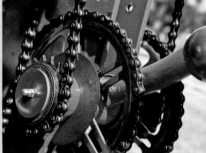

# toon

*God straft onmiddellijk* – roughly translated as 'God punishes instantly' – is a Dutch expression delivered to Toon by his wife, Riek. It could be considered rather a harsh outburst from your spouse, especially since Toon had suffered a broken collarbone after plunging head over heels on his penny-farthing. However, Riek felt Toon had got his comeuppance after admitting his furtive motive for riding the penny that day was to offer him a suitably high vantage point from which to observe pretty ladies on their bikes!

'My fascination with bikes comes not from a love of cycling great distances, instead more the mechanical inventiveness of the machine. When I stumble across a bike of interest I spend hours poring over the engineering behind it. This started, I guess, with my first bike, a 1910 FN (Fabrique National d'Armes de Guerre, Belgium) with a cardanic drive shaft. In simple terms, it's a chainless bike powered by a drive-shaft between pedal and wheel. It was given to me about 50 years ago by the widow of the previous owner. The appreciation of the bike's engineering led me on a path to collecting many other varied examples.'

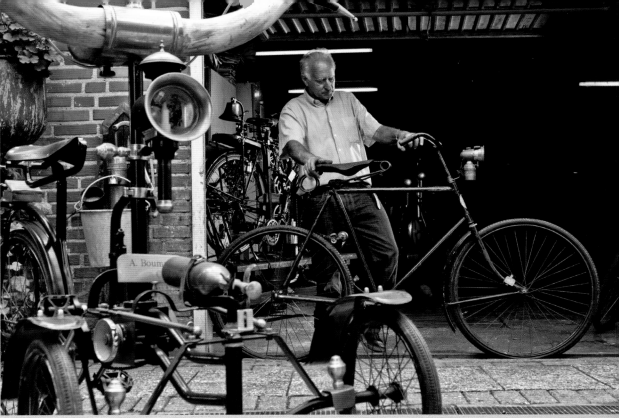

As for Toon's bicycle creations, well...they're the recipes of a sheer genius inventor and engineer – with a side order of crazy. It would be a challenge to find elsewhere a collection comprising a monocycle, clog bike (complete with patriotic ankle socks) or a bicycle adorned with four-foot-wide bullhorn handlebars.

'My creations normally stem from finding redundant materials or objects – it gets my mind ticking. For example, I was involved in repairing a clock tower – my mind wandered, as it often does, and I started to consider whether I could make a functional clock with bicycle parts – despite people saying, "It's impossible", I managed it.

'All my bicycles are cherished. However, given the choice to take only one to a Pacific island (navigable only by bike) I would take my Adler with a three-speed gearbox in the bottom bracket – a perfect ride with good solid construction. And despite my doctor's recent advice to be careful after my hip replacement – it will take more than that to stop me – I'll still be inventing for many years to come.'

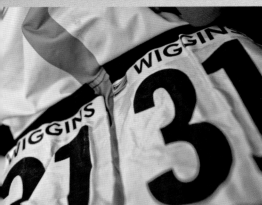

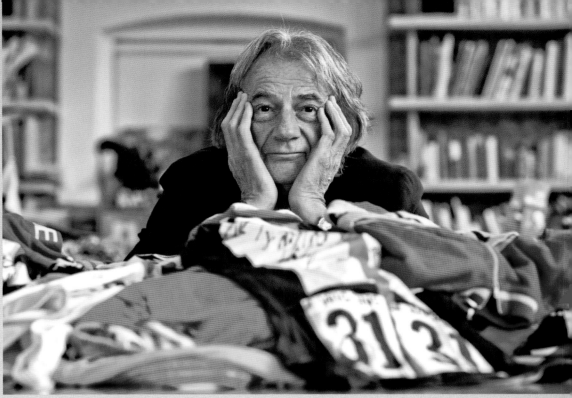

# the yellow jersey

Were it not for a rather serious cycling mishap in his youth, it could quite easily have been the case that Sir Paul Smith would not today be considered by many to be Britain's most successful fashion designer. Instead, acclaim may have been his through formidable cycling success...who knows? The fickle hand of fate was at play. However, throughout the years of success for Sir Paul, he has retained his immense passion for cycling.

Among the many bikes that adorn his office, you will find 6.9kg of pink carbon-fibre Principia road bike, a stunning Mercian with welding carried out by his own fair hands, and a collection of frames with the signature Paul Smith stripe, a particular favourite of his being a beautifully crafted hand-painted example.

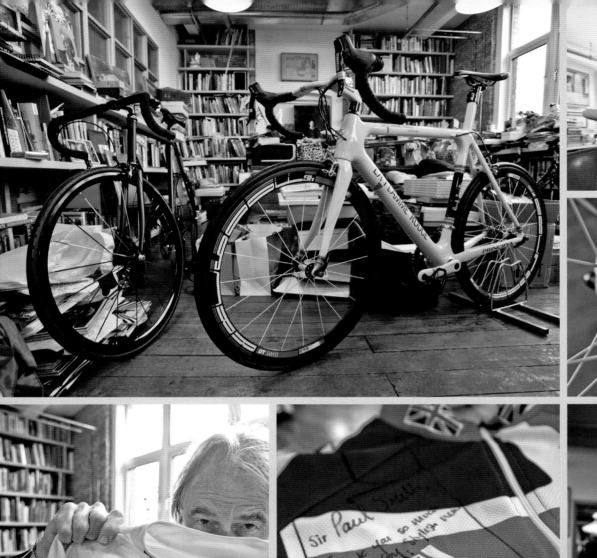

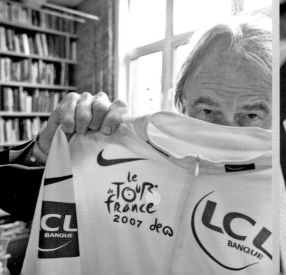
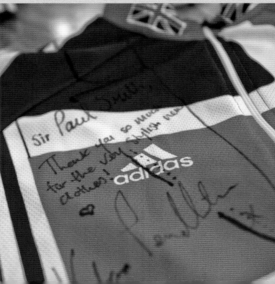

Sir Paul Smith
Thank you so much
for the very stylish new
clothes!

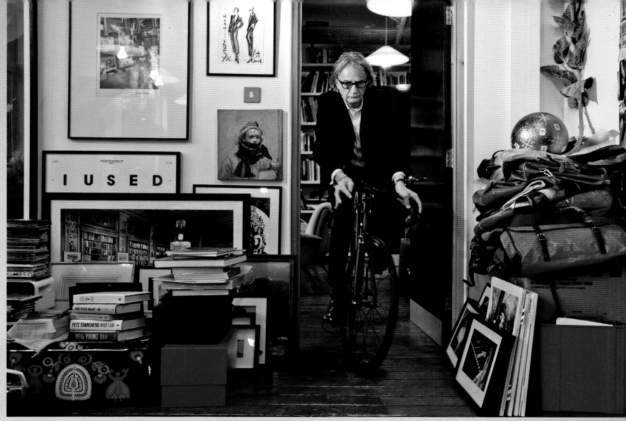

'I receive all manner of wonderful, inspiring – sometimes bizarre – objects and collectables sent to me,' explains Sir Paul. However, with an obvious love of fashion and cycling what else would you expect him to collect than...well, cycle jerseys! One of the perks Sir Paul enjoys for being on first-name terms with the world's cycling elite is being the obvious recipient for a signed winner's jersey. So within his office are a multi-coloured bundle of jerseys – all unframed, as that would prevent tactile appreciation.

With a passion for cycling that runs so deep an intriguing 'what if' situation arises, one that Sir Paul admits is a tough conundrum – would he forgo his fashion empire and with it all the successful trappings of life it has brought for the opportunity to have worn the famous yellow jersey? He admits it's a tough question, and for once he seems stumped for an answer!

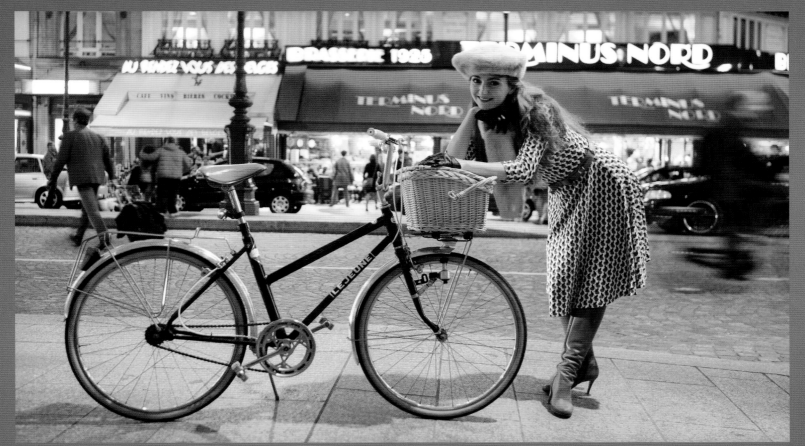

# lejeune

'I'm no expert on velos, however I knew I wanted something different. 'It was instant attraction when I first saw my 70s Lejeune bicycle', explains Parisian burlesque dancer Sucre d'Orge. Lejeune are classic French frames famous for their aesthetically pleasing detail at affordable prices, and a Lejeune was ridden in the 1972 Tour de France. 'I love its shape; in French you would say, *"il a du chien"* (i.e. it has an unusual charm). It's not the most beautiful bike ever made, but everything about it pleases me; we have an affinity, the odd feeling we are "alike". I love being elegant both on and off the stage. So when it comes to cycling attire, I have a penchant for wearing vintage clothing; it's romantic – embodying a way of life from a previous era...glamour is not reserved solely for burlesque! At weekends I enjoy nothing better than a cycle ride to Bois de Vincennes, especially on Sundays when cars are prohibited along the Seine. It's a joy to cycle in Paris – and I see it in a different way now; smaller and nicer.'

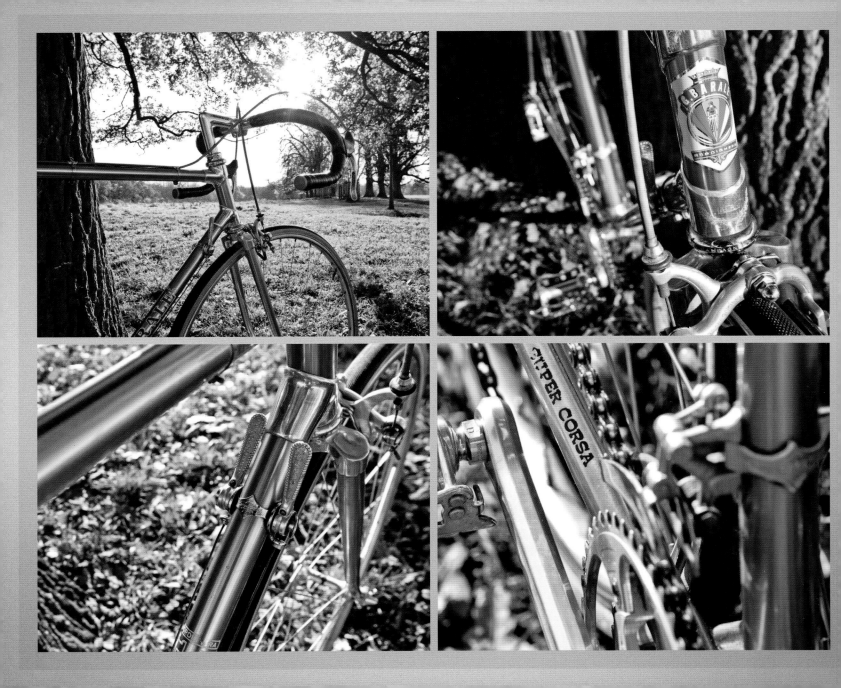

# alan super gold

'I'm always on the lookout for (usually old) bikes,' explains John Abrahams. 'My late father, Abe, wasn't renowned for his bicycle knowledge, but for his expertise on vintage fishing tackle he couldn't be touched. However, he was well aware I knew a thing or two about bikes. My father was also a bit of a car-boot sale hound, so a father-son agreement was put in place, whereby he'd phone me up of a Sunday morning and describe a certain bike he'd found. Sometimes they'd be cool, but more often than not they fell well below expectations! During one of his more adventurous car-boot sale visits, in the Mayenne region of France, he found this late 70s Alan Super Gold edition for 10 euros – he'd bartered the guy down from 15! I was impressed – it seemed his bicycle knowledge was improving.

Alan bike frames are extremely rare, and feature interesting engraving on the lugs (as seen on the chrome ones featured here). 'I was keen to see what other gems he could find, but sadly soon after he died from cancer, says John. 'On face value it may not appear to be the world's most interesting bicycle story compared to others; however, you can see why, to me, the bike has such a strong sentimental value, which means it's a keeper.'

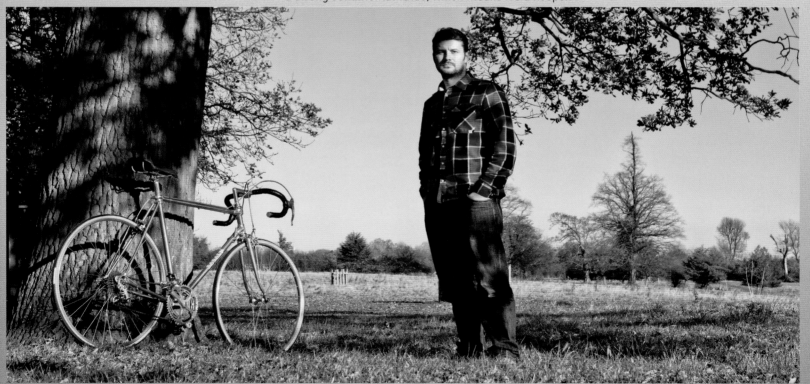

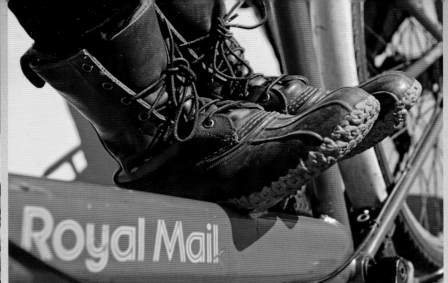

## royal mail special delivery

'It was the summer of 2011 and I was volunteering for the Bicycle Empowerment Network in Marina Da Gama, South Africa. The network receives unwanted bicycles from around the world and trains locals in bicycle maintenance and business management skills, with the aim that they set up bicycle shops within their own communities,' explains Elizabeth Jose, founder of the New York women's cycling group 'WE Bike NYC'.

'A container laden with bikes arrived from England with a consignment of 70 Pashley Royal Mail bicycles – love at first sight! The container was emptied and contents sorted, ready for shop owners to select their stock. At this point I became rather attached to a certain Royal Mail five-speed MailStar bike (hence 'MS12', presumably), so much so that when the proprietors' trucks arrived to take another batch of bikes, I feared my beloved bike would be taken and my stomach dropped! I decided to put the bike aside, away from prying eyes, and just ride it around while I was there – well, that's what I told myself anyway.

'My stint at volunteering was coming to an end and I prepared to say farewell to everyone – including to the bike. I'd contemplated the notion of taking it back to New York – how cool would that be! I finally spoke to the organisers and they agreed I could purchase the bike in exchange for working extra hours and on the understanding that if ever sold the money would go back to the network. Deal done, now how to get it home? This became a major organisational project! As I had already brought my own bike with me, I didn't have the option of taking two home on the plane.

'Long-distance cycling was no stranger to me. Several years earlier I had cycled across America – however, I had the small matter of the Atlantic to cross! The word

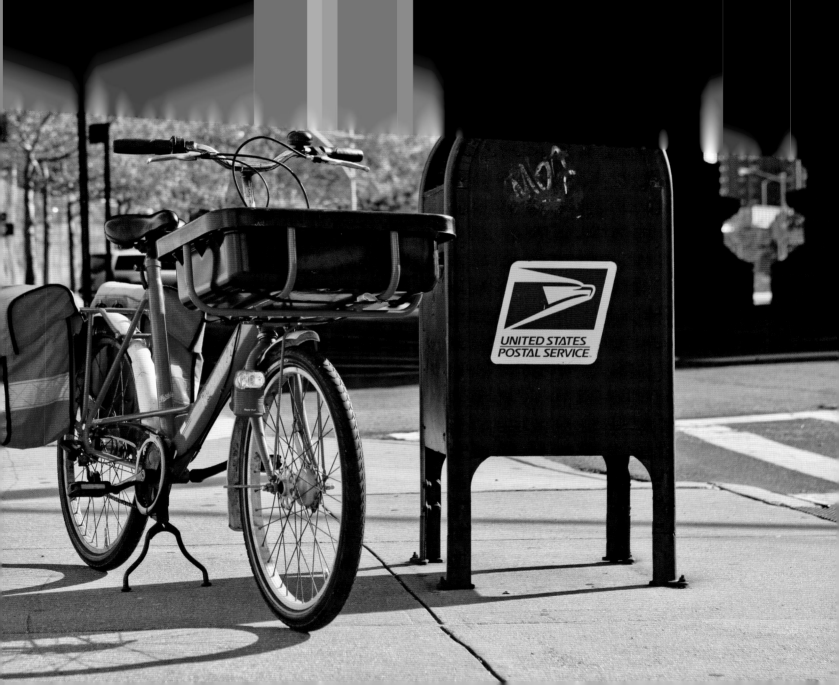

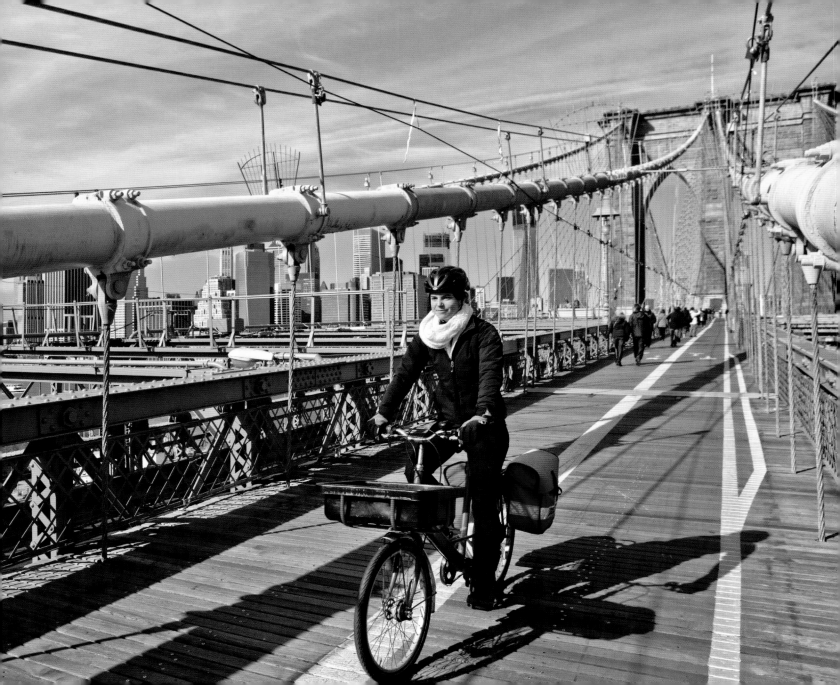

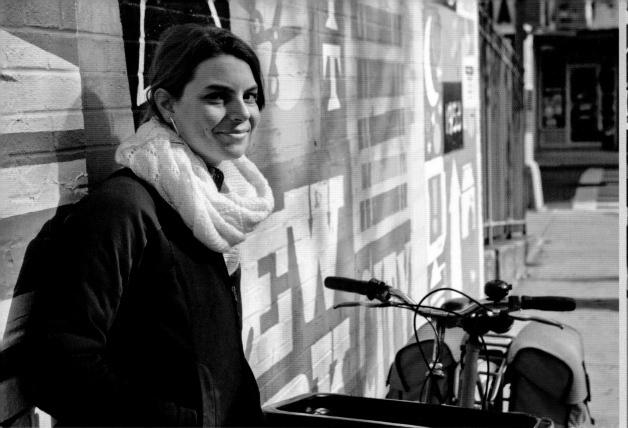

got round and I was told that posting a one-metre box to America was around $200 – perfect! So I duly took the bike apart down to the bare bones – every nut, bolt and washer – in order to squeeze it into the box. It was then loaded on the station wagon and driven to the post office. Proudly I presented my beautifully packaged bike with the request, "I would like to post this to New York, please." I received an unexpected reply: "Sorry, the box must be a total *combined* width, depth and height of one metre." Other shipping options exceeded $2,500! Ouch! I wanted the bike, but that was outside my means – but I wasn't going to give up.

'I was inundated with imaginative suggestions of how to get it back home. One was that I take it to the port, sweet-talk a captain of a container ship destined for New York (most likely via the rest of the world) and ask him to give me a call when he docked – this seemed risky!

'Finally, it dawned on me that another volunteer was flying to Chicago and, as luck would have it, she was travelling light on luggage – excellent, spare kilos! So off it went to Chicago and upon arrival it was posted on to New York.

'So there you go: England; South Africa; Chicago; New York. It's a wonderfully versatile bike and British tourists' reactions to the familiar sight range from double takes to comments of "You did what?" – I sometimes can't believe it myself.'

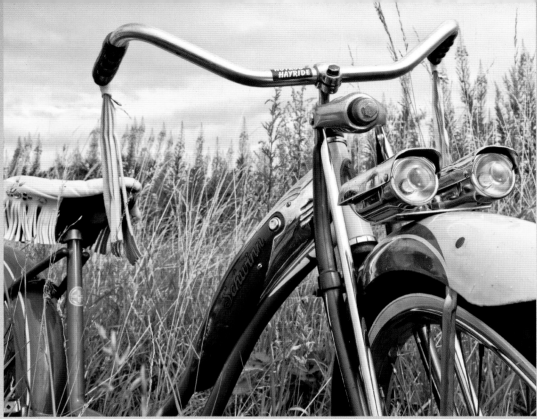

# schwinn

It's up there with some of the cleverest ruses – seemingly buying a gift for a loved one, when instead the motive is a way of adding to your own collection.

'For a while I'd been looking for a bike as a quick and stylish way of whizzing around festivals with my husband Loggy (I don't know how he got that nickname when his real name is John, but since a young age he only responds to Log/Loggy),' explains Estelle. 'Anyhow, we're both big fans of the vintage scene – music, clothing, lifestyle and a home brim to the top with eclectic Americana. Log knew very well I hankered after a classic American Schwinn bike.

The Schwinn's distinctive 'motorcycle' style and collectible status have a great appeal to vintage enthusiasts, who can put up with the rather heavy weight that results, but find it hard, like Estelle, to resist customising and accessorising their pride and joy. She continues, 'So, to my surprise, he bought me one as a Christmas present. He told me to be patient, as it was coming over from California. Even better, I thought, a fresh import with not even a tyre rotation on British soil! However, I wasn't banking on the shipping method being so, how can I put it, unique...to say the least. Instead of bubble wrap and

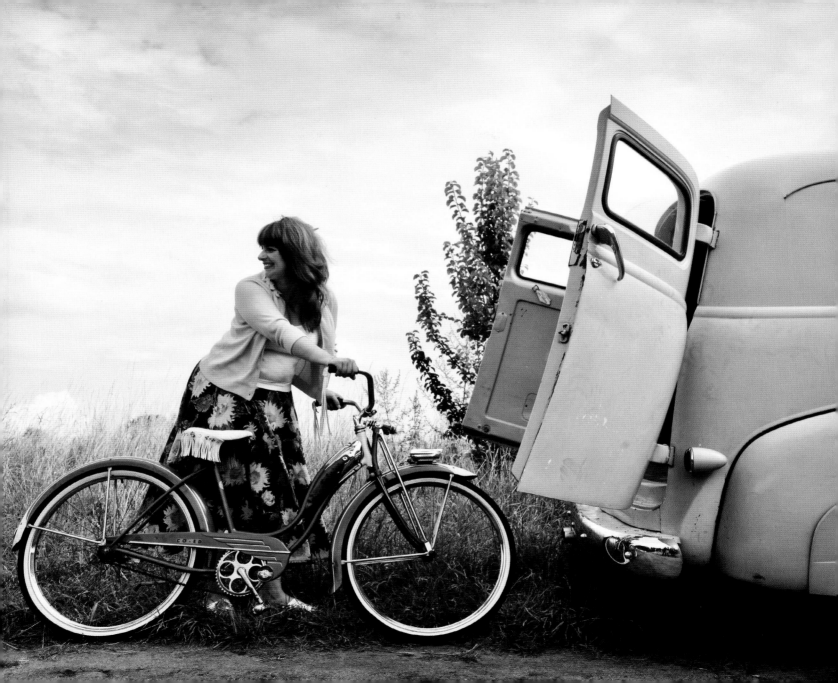

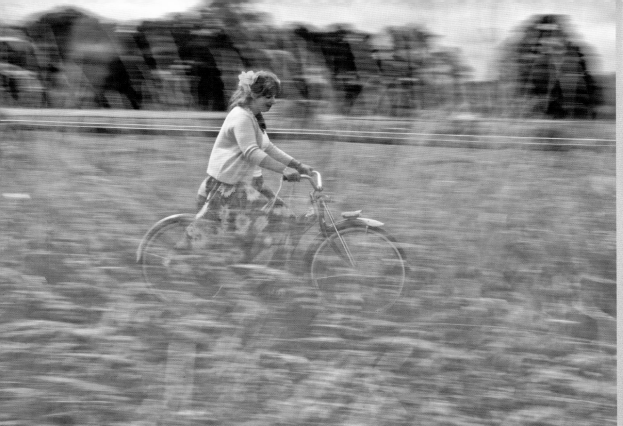
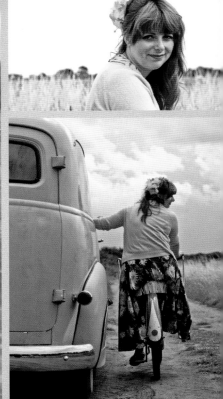

cardboard, Log decided a 1950 Chevy panel truck would be far more suitable. Yes, that's right, my lovely husband, after finding the bike for sale on the internet, carried on shopping and then found the truck – ingeniously crafty.

'I'm sure that when searching for the bike he did have my best interests in mind, it just happened to be a good way of getting the bike over to England. In his defence, the truck was on both of our wish lists, so all was forgiven.

'I love my 1955 Schwinn Co-Ed. Not the lightest bike around, but it's comfortable and oozing with lovely classic American style. So, there we go, I got my dream bike via somewhat ulterior motives. But a word of warning to you all – watch out when a loved one says, "Look what I've bought you…" There may be a hidden motive!'

# raleigh chopper

'Picture this. It was the early 1970s. I'm playing football on a glorious summer's day near my home in Notting Hill, London,' explains legendary DJ Norman Jay (who can perhaps count the Queen as a fan after being awarded an MBE for Services to Music).

'It was a game-changing moment when a kid riding a bike, which was quite unlike anything I had seen before, glided past. My jaw dropped. In my mind everything fell silent and colours faded to mono apart from, that is, a bright yellow Raleigh Chopper. In what seemed like an age, but in fact was only seconds, I snapped out of my daze and along with everyone else in the park sprinted over and yelled in unison, "Let's have a go!"

'Back then it was the two-wheeled equivalent of a Rolls-Royce. However, looks are misleading – it turned out to be a pig-of-a-bike to ride. I didn't care, though: it looked cool and that's all that matters to an impressionable kid. I knew that with a price tag of £38 it was unlikely I'd be owning one soon. In one fell swoop it would've relinquished my father of his weekly wage packet. So a Chopper, along with a Johnny Seven toy machine

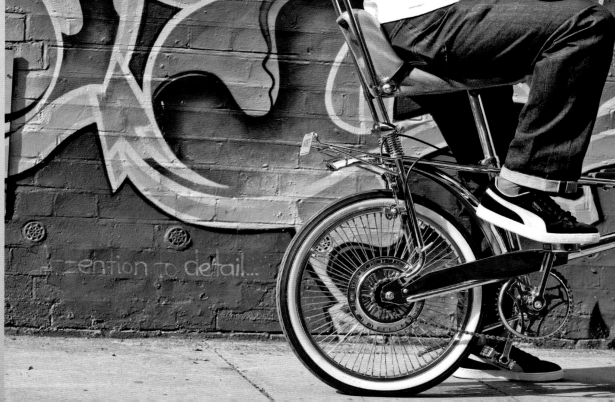

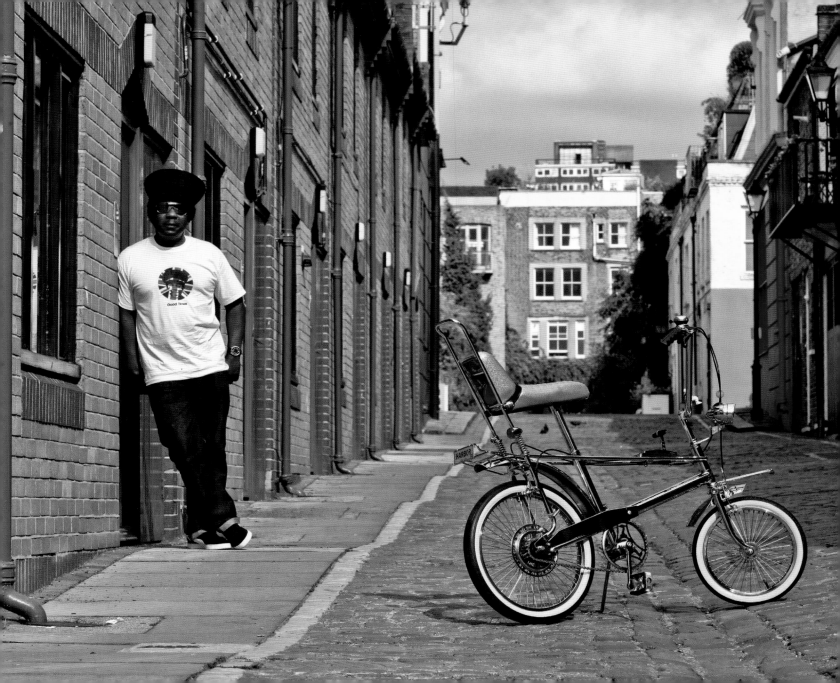

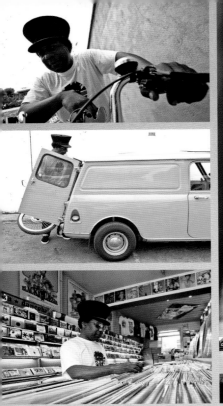

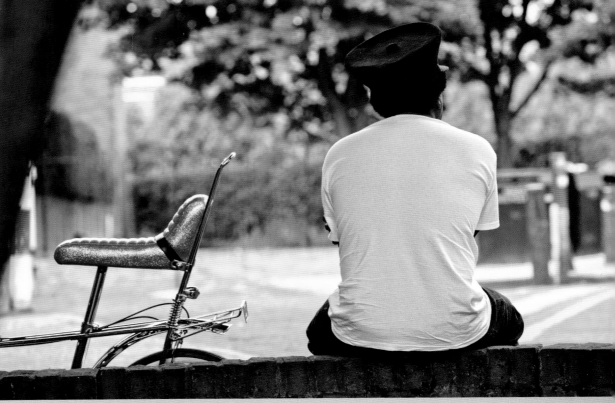

gun (another must-have toy of my era) was added to my wish list. Instead I made do with my own bike but added a set of Chopper-style handlebars and a copious amount of front lights, which from a head-on approach (though not a degree to either side) you would've sworn was a Chopper.

'My love for Choppers never really diminished. In the late 80s, on a snowy winter's day with cash in my pocket, I spotted a purple Chopper in a junk shop; and it happened to come with a box full of enough parts to build two further Choppers. All this for under a tenner! At last, one thing less on my wish list.

'So to the present day – during which time I've managed to accumulate 18 Choppers, all of which are dotted across London in any spare space friends and family have. It's rather like having my own personal cycle-hire scheme ready for use whenever I'm nearby. The collection will get reduced, I'm sure, but I'll always keep some.'

# matteo

'I bought the bike with the proceeds of a TV commercial I featured in,' says Matteo Scialom about his fixed-gear Gitane (French for 'gypsy'), a maker whose most renowned bikes were produced in the 1950s and 60s, although his is a more recent model. 'I don't have a car; not much point in Paris or any major city come to think of it, so for me it's the ideal way of getting around. With my bike I can explore Paris and discover unexplored non-tourist places that are hard or near impossible to reach by car. I love the connection that a fixed-gear bike gives you. However, I don't trust my legs when they're tired – hence the brake. Cycling is not the only thing in my life, but it's a big part of it.'

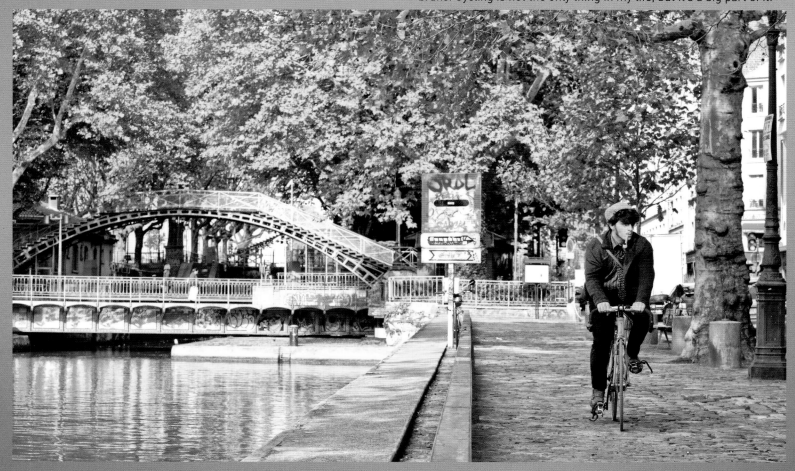

## days gone by

'I'm always keen to talk about bicycles. At one time I was an avid road racer; however, now, along with my wife Wendy I tend to tour, cycle to work and use them for general lifestyle pursuits – namely as a form of transport to and from the pub,' explains Simon Doughty. He's a man who knows there's a place for modern, breathable, moisture-wicking fabrics, but as you can see it's evident they won't find a place in his wardrobe any time soon. His bike stand is firmly placed in a bygone era in which a sensible wool knit would suffice.

'My bikes form a cross-section of styles and vintages. As you see, here is a durable and heavy 1930s police bicycle, not so much designed with considerations for speed, but in my view far better suited for a constable to apprehend an offender with a well-aimed handlebar. Plus several, dare I confess, modern counterparts, including a 70s Colnago road bike and a 80s Holdsworth mountain bike. The basic principles remain the same, and it's nice to see how things have progressed.

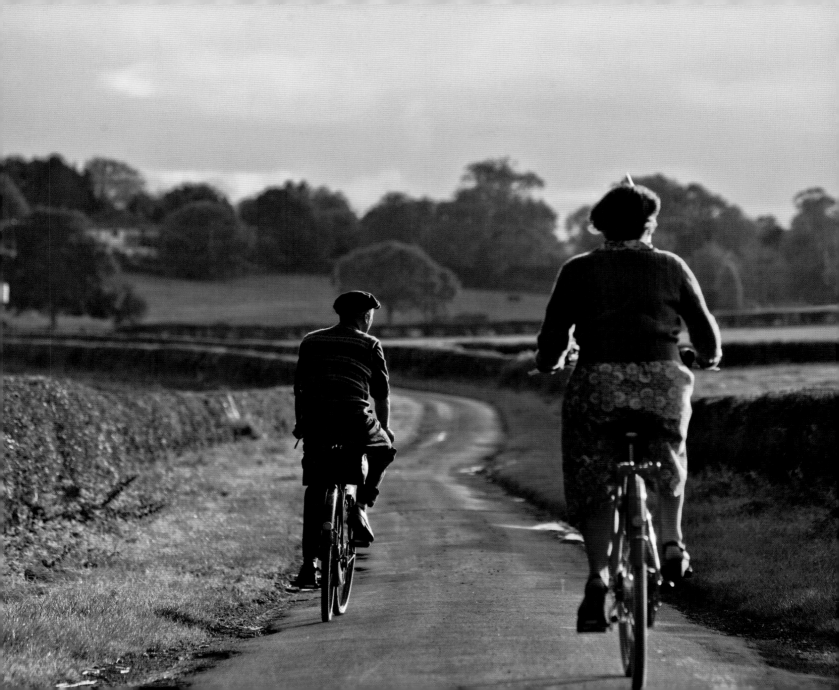

'Our trusty H Van lends itself perfectly as our rest-stop-cum-overnight-lodgings for our longer cycling trips. It's not uncommon for us to tot up 2,000 miles or more a year. With our route planned we head off, secure in our minds that the van will be a cosy retreat on our return. A comforting thought when nearing the end of a pleasant day's cycling.

'For many years bicycles have served as a major pastime for us, so it's safe to say I can't envisage a time when cycling won't be a regular activity on our calendar. And as for our choice of apparel? Our bikes may change, but our style never will.'

# vélo vintage

Hugo and Edson from Vélo Vintage in Paris obtain their shop stock by travelling the French countryside and piling up their trailer with unloved bikes. 'Purchasing velos in this way is becoming more difficult as appreciation for old bikes is on the increase, so suitable examples are becoming scarcer. However, more often than not we come back with a good haul. It's rather like fishing for bikes – you know they're out there, but it takes time and patience to catch them.'

The cycle pictured is a Stella, a French company founded in Nantes in 1909 that supplied the winning bikes in two Tours de France in the 1950s.

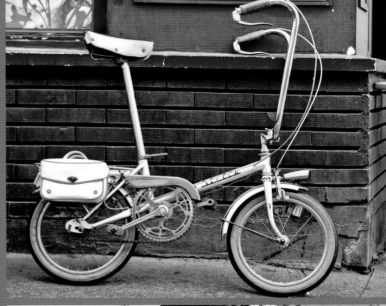

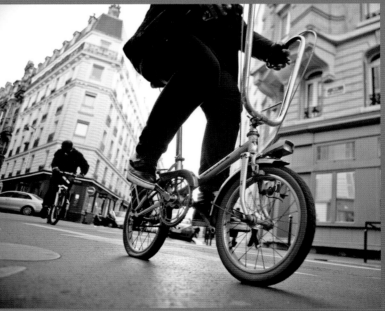

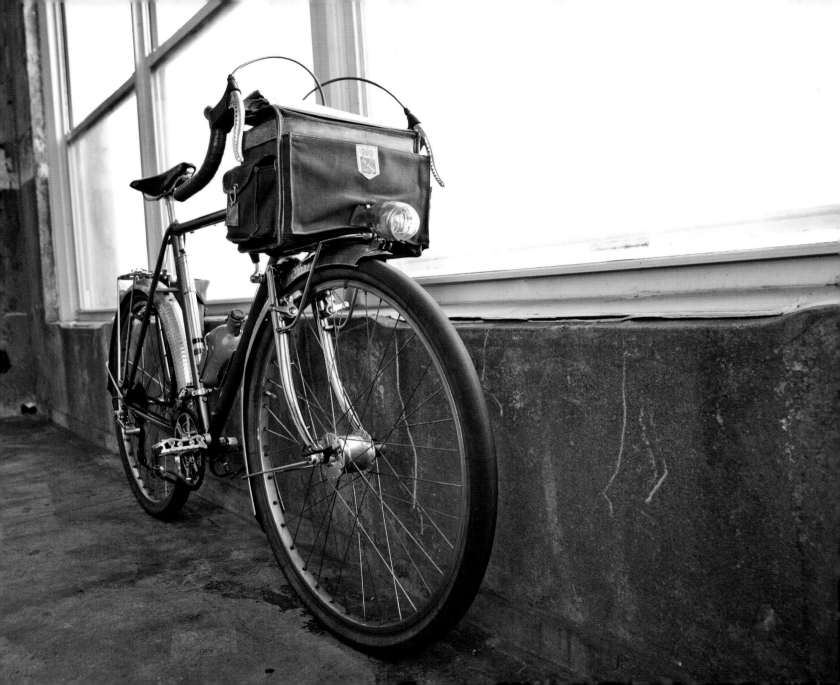

# the perfectionist

'For me, the closest thing to a perfect machine for transport where the passenger is also the engine is the touring bicycle, called a *randonneur* and built to order in France for wealthy amateur enthusiasts. Fully integrated, rugged, lightweight and elegant bicycles designed for comfort as much as for speed, they're also reliable all year round, on good roads or bad, night or day, climbing patiently uphill or speeding down at dizzying velocity, with everything you might need to be wholly self-reliant for a weekend away,' explains Guy Lesser from Brooklyn, New York, about his lightweight, 18-speed Johnny Coast, complete with handmade racks to take the canvas and leather panniers.

'Accordingly, it's odd that for more than a generation the whole era of "constructeur" bike builders, like Alex Singer and Rene Herse, which flourished after World War Two, was largely forgotten. That is, until roughly a decade ago, when a group of American frame builders, in particular J.P. Weigle of Connecticut, began exploring and sharing

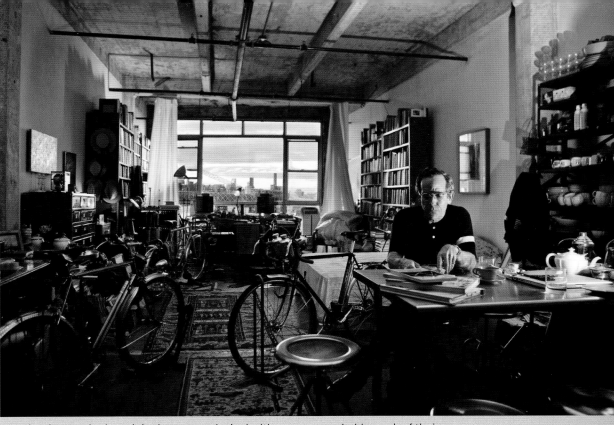

exactly what made the originals so superb. And with some remarkable work of their own it's rather shaping up as a renaissance for the randonneur.

'In my own case, everything began with love at first sight (which is to say I stumbled on a few images of an early Rene Herse), and I then spent over two years working on a "build" of my own. My plan originally was to buy a vintage bike, but I figured I would learn far more if I experienced being a *sur mesure* (made to measure) customer of a living frame builder, and having to choose every nut and bolt myself. Besides, what were the chances I'd find an original with exactly the components I preferred, tailored to an ideal "fit", and in sound enough shape to be a reliable ride? The rest, as they say, is history. Or at least a very minor footnote to a fairly obscure corner of it!'

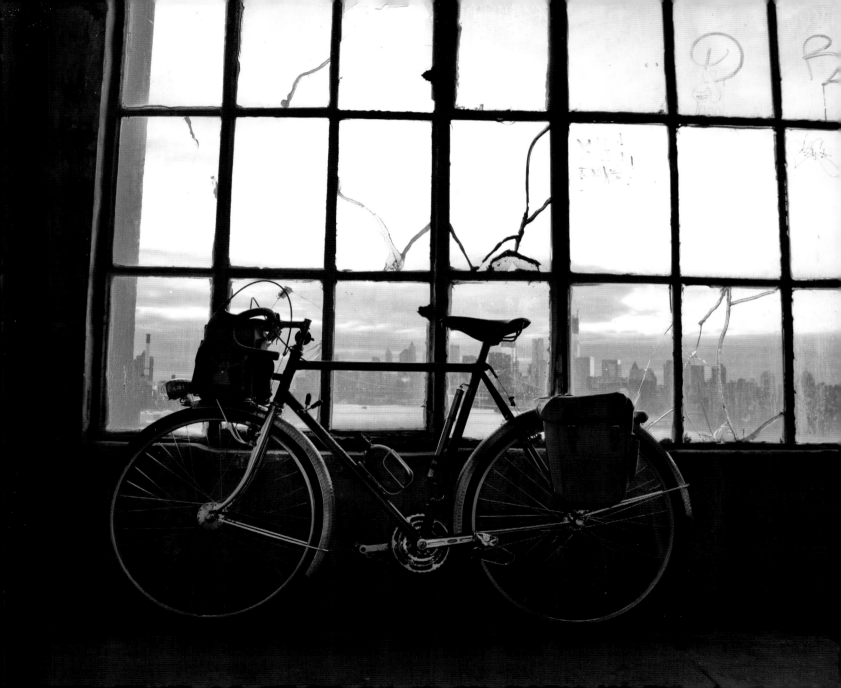

# an affair with phillips

'I've fallen in love with many bicycles but have entered into long-term relationships with only three,' explains Hannah. 'Cycling wasn't a major part of my adult life until moving to Cambridge. You can't really claim to live in "the bridge" if you don't cycle; I realised this from the moment I stepped out of the train station and into a sea of bikes attached to absolutely everything that the rider could get a chain around. After a few stopgap bikes used to commute between three part-time jobs, I purchased my 1920s green Phillips ladies' town bike. This is when I became addicted to riding a "Rolls". In my view a bike with Rolls-Royce status must be made of steel and a cumbersome beast – not at all a bike for a short junket or for carrying onto trains. The bonuses are they're a joy to ride, you hardly feel any bumps and they're built to last...well, almost.

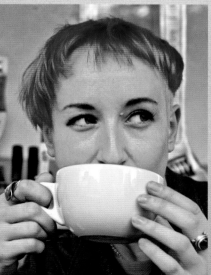

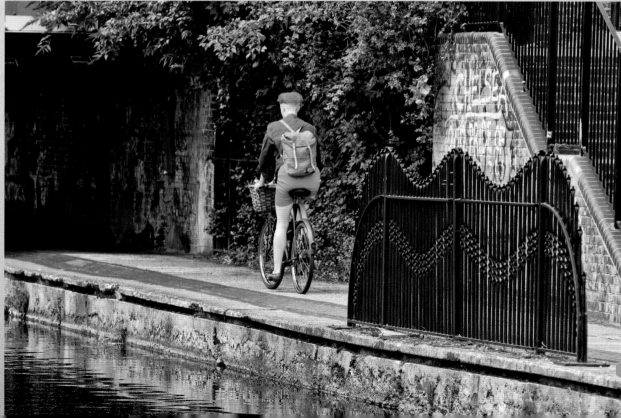

'After a few years my Phillips started to fall apart and it came to a head when the frame promptly snapped. Undeterred, a tip-off led me to John Wayne – welder extraordinaire – who could apparently fix my bike. It transpired that bikes weren't entirely his forte. When I picked up my bike post-op it was probably more dangerous than when I took it in! I soon gave up hope that my beauty would ever be back to its former glory. However, with the help of a good friend and "bicycle surgeon" the Phillips is well on the road to recovery. In the meantime, I'm having a dalliance with a 1950s Raleigh and a borrowed beauty – a George Longstaff racing bike. Then again, I'm not sure just how brief this affair will be – considering that I recently took it on a 53-mile trip and had the ride of my life!'

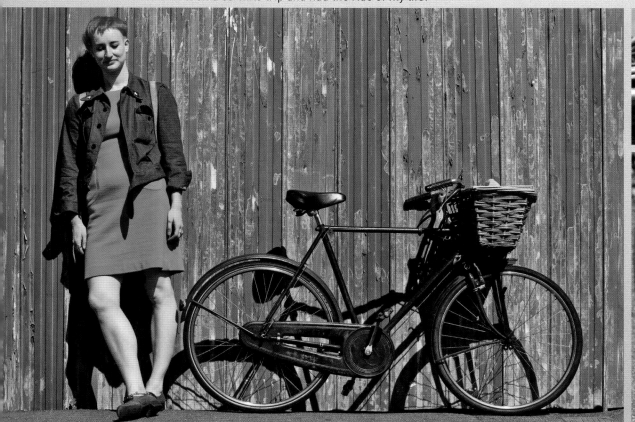

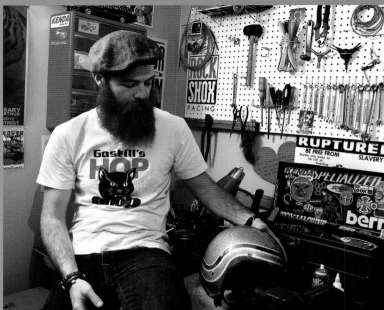

# gaskill's hop shop

'At the shop I'm often compared to a raccoon! It's a fair comparison, as more often than not I can be found scavenging through trash, picking out this'n'that, looking for things that can be set aside and put to use on a future creation,' explains Tennessee-born-and-raised Adam Gaskill from Gaskill's Hop Shop. It's the place for highly sought-after, gnarly, two-wheeled bikes best described as having a 'fictitious' history; made to appear old, though created in the present.

'Assembling a bike from partly scavenged doohickeys is a pleasurable way to build. In fact "build" doesn't really sum up the process; it could be more accurately described as "sculpting". Try a part, see if it works and then hone it harmoniously into place. Sure, the bike evolves from an original concept and all the time I'm conscious that it could meander in a new direction; especially when something comes to light after a recent dumpster rummage.

'To honour my roots and as a nod to the state animal of Tennessee, I proudly hang a raccoon tail from my bikes. And, of course, all are detailed with my intricate signature pin-striping. When asked to sum up my bikes, I say, "Go big or go home!"'

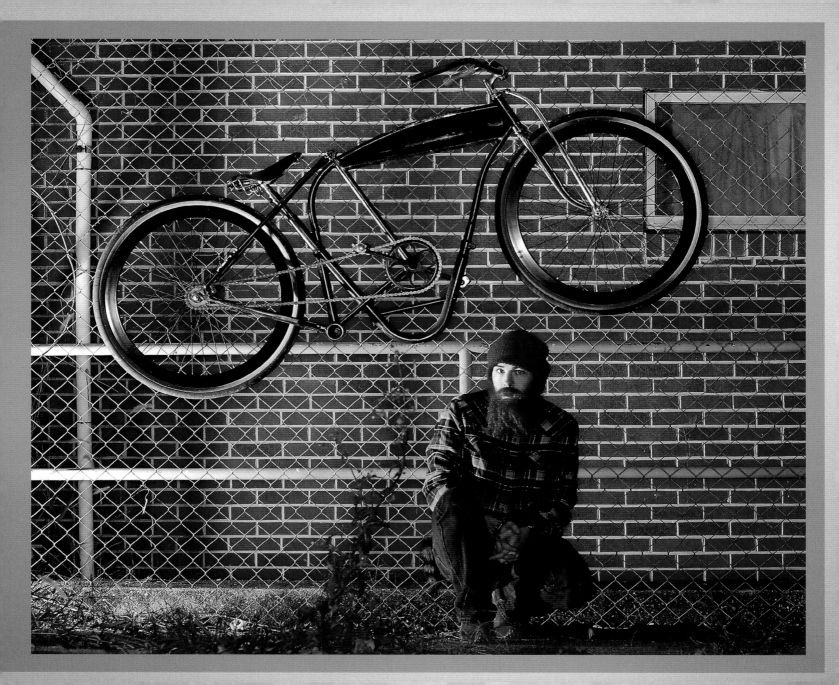

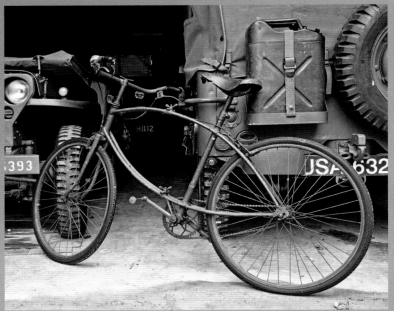

# bsa folding bike

The 1942–45 WW2 BSA Airborne Bicycle was taken into battle either via its own parachute or being carried by a paratrooper and released moments before landing in enemy territory. Although used in battle, it saw less active service than planned. The aim was to get soldiers mobile; away from the drop zone and into battle far faster than on foot.

# mizutani super cycle

An example of a vintage Japanese Mizutani Super Cycle in pristine condition. Note the fine detail on the front mudguard, the chrome lugwork, the dynamo and the old-style centre pull brakes.

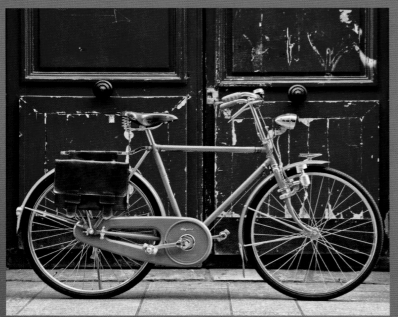

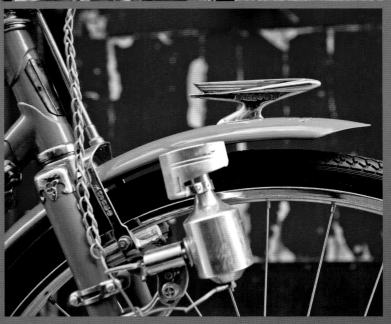

# elswick-hopper scoo-ped

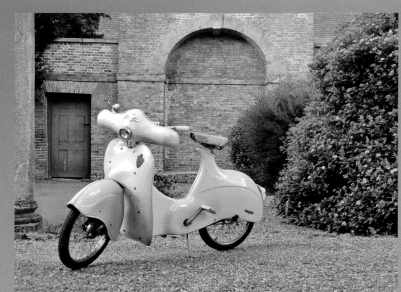

The Elswick-Hopper Scoo-Ped was the ultimate in streamlined bicycles from the early 1950s, and only a small number remain. It was every teenager's dream bike, by way of its scooter-esque similarities – the only drawback was being stopped by overzealous police officers assuming, wrongly, that it was in fact a moped.

# charrie's café

'I love exploring the unusual things you can achieve with bicycles – and I really appreciate good coffee. So what better way to combine both my loves than "CharRie's Café"... my bicycle café,' explains Rie Sawada. 'In 2010 in Nagoya, Japan, I set up operations outside Circles bike shop and brewed my coffee every Sunday until I left Japan to travel overseas.' Rie can now be seen pedalling around Berlin and attending many cycle events with her specially adapted vintage Nishiki road bike. She is a welcome sight, serving her own expertly hand-brewed 'Miracle' coffee and home-made cookies.

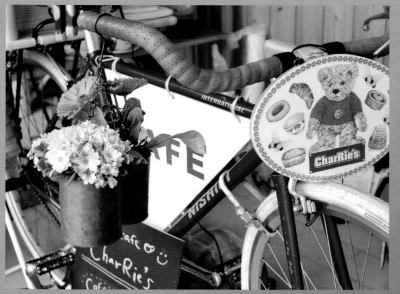

## nuclear bunker tunnel

These bicycles were once used for a hasty passage through the 91-metre entrance tunnel at the now-decommissioned 'secret' nuclear bunker at Kelvedon Hatch, Essex.

## critérium des porteurs de journaux

The Critérium des Porteurs de Journaux was a hugely popular and well-reported 24-mile annual cycle race on the cobbled perimeter streets of Paris. One difference between this and many other races was the requirement to have 15 kilos of newspapers strapped to your cargo rack. After all, the winner of this race was declared the fastest newspaper delivery rider in Paris. Typically, the delivery of Parisian newspapers to kiosks all over the city was via cargo bike – this was the chance for riders to show off their skills. The races started in 1895 and continued until the mid-1960s. Miq Keeland's fine example of a *porteur*-style bike is typical of the 1930s era and, who knows, may well have been used in said races.

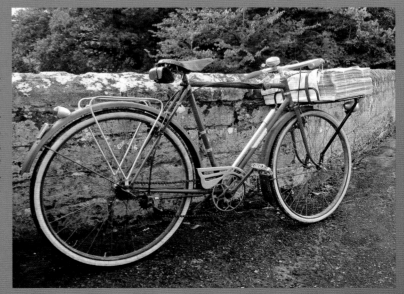

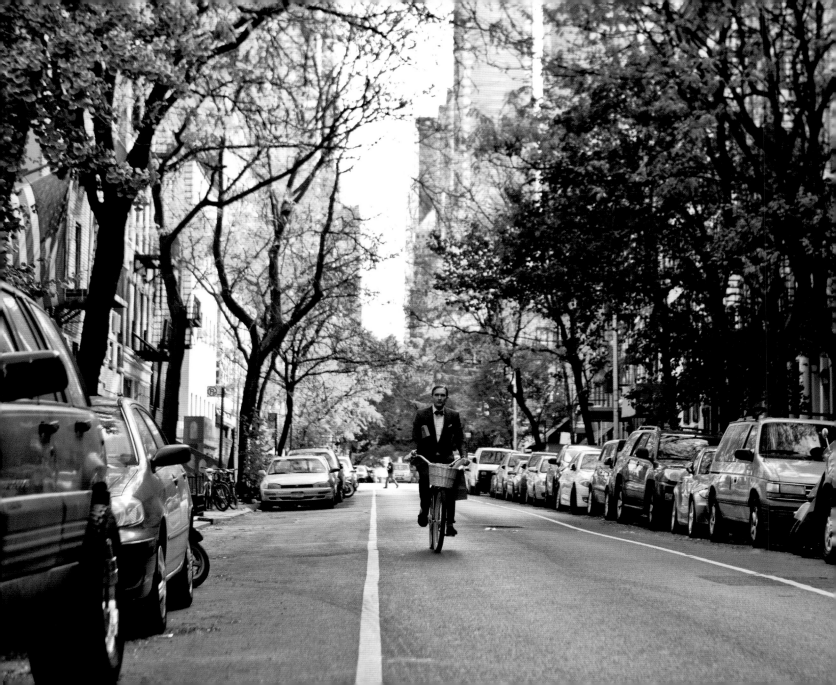

# making a difference

As you will see within this chapter, the bicycle seemingly has the ability to educate and adapt to help those with varying degrees of need. In some situations it's true to say that other forms of mobility can provide similar assistance. However, the bicycle succeeds where others fail by way of its friendly demeanour and non-pressurised approach; its independence from any power source other than human effort is a big plus too.

First to Ghana, where bikes play an important role in changing people's lives for the better, by providing an accessible and reliable form of transport. Remote communities have the chance to increase prosperity by establishing a bicycle business and motivating the local economy. On the other hand, for a developed metropolis such as Beijing, the bicycle has for decades taken centre stage as a form of mobility for the masses. Despite China's huge economic and social advances the bicycle is still relied on for business, as it can easily navigate the narrow bustling streets.

A mobile library in Portland, Oregon, provides escapism and an educational lifeline for those less fortunate. For others, the bike serves as a rapid platform for creative expression that's ready to be deployed at a moment's notice. For one organisation the bicycle is used as a means of education, by drawing parallels between energy consumption and pedal power.

More light-hearted but equally important examples include an individual on an eccentric mode of transport making a stand against capitalism. While for Matt at 'Fine and Dandy' the bike is his trusty sidekick with a vital duty to perform – rescuing those in the midst of a fashion crisis!

For many in need of help – in some cases, life-changing support – the bicycle is 'making a difference' in a quiet but very noticeable way.

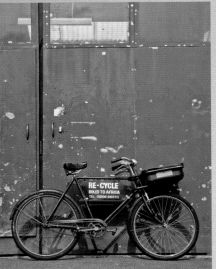

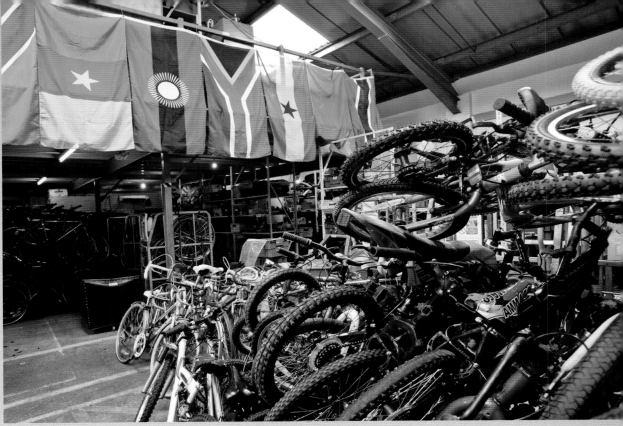

## re-cycle

'It's far from an ill-thought-out cliché to say that bicycles can change people's lives for the better. Since our programme started in 1998 we've seen first-hand what actually can be achieved. Benefits that are sustainable and spread throughout needy communities in Africa – all with just unwanted bikes,' explains Derek, who has been working with Re-Cycle since 2006 after redundancy prompted him to seek a career in which his time made a real life-changing difference.

'For a moment, consider the transport infrastructure behind daily items from supplier to consumer. Imagine that same process without the ease of mobility that we take for granted. Our process is simple; we encourage the donation of bicycles lying dormant in garages and sheds. Once at our depot, we either strip down unusable bikes into parts or prepare serviceable bikes ready to be shipped out in a container, holding on average 400 bikes. On arrival at our partner organisations in Africa, the bikes are refurbished before distribution. Another aspect of the charity is teaching

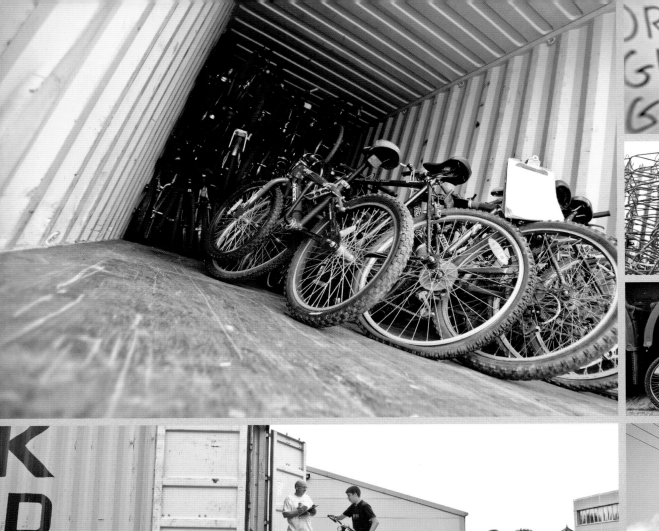

DR Congo        564
                 80
Ghana          15,490
Gambia          1,574
                  475
                  350
                  260

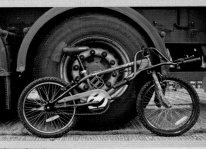
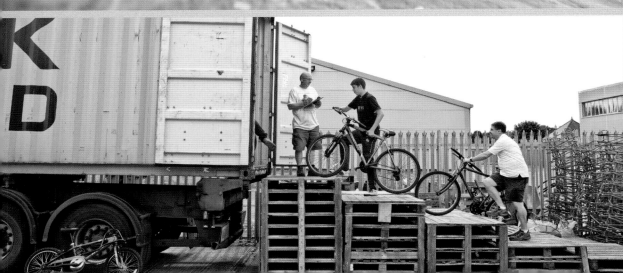
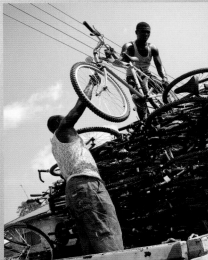

bicycle maintenance – it's all well and good giving someone the chance of mobility, but you want it to remain that way.

'Many people in impoverished regions of Africa have little or no access to transport. Without transport, individual or community development is slow or impossible. Bicycles lighten the load of what are seemingly simple but time-consuming, labour-intensive tasks; collecting water and firewood are all hastened with the addition of a bicycle. The time saved can then be used for social improvement and increased employment opportunities. Also, bikes give small-scale traders and farmers the chance to reach out to new customers in more remote areas.

'We've now sent over 100 containers, nearly 42,000 bikes, to an increasing list of countries in Africa. Our achievements wouldn't have been possible if not for the wonderful support of people that give up their time, money and – most importantly – bikes!'

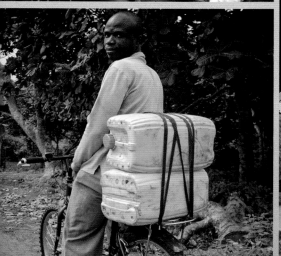

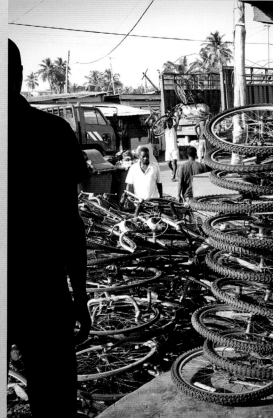

# beijing cargo bicycles

In the urban metropolis that is Beijing, the use of heavily laden freight-hauling three-wheeled bicycles still exists and indeed flourishes. This occurrence is in part due to laws restricting the use of large trucks from entering the city, thus encouraging businesses to shift to smaller, greener forms of transport. Much can be learned from this practice, especially in ever-expanding, overpolluted cities around the world.

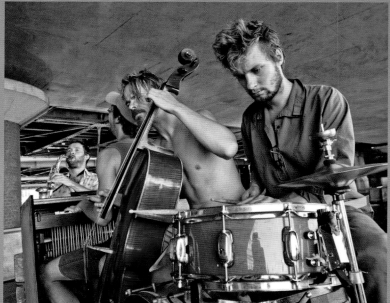

# the bike band

In order to bypass Amsterdam's regulations regarding public musical performances while stationary, the talented Bakfiets Band came up with a cunning solution to bring their mixture of jazz and other music to the city's inhabitants. Namely, ingeniously converting an old fishmonger's bicycle cart into a unique mobile stage, incorporating a reduced-size piano, drum kit and cello, all propelled by the saxophonist.

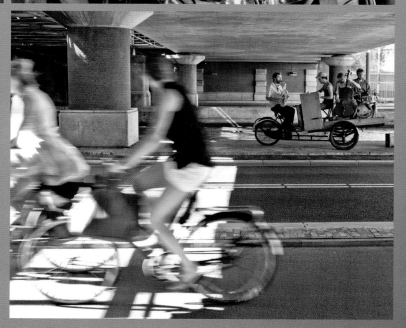

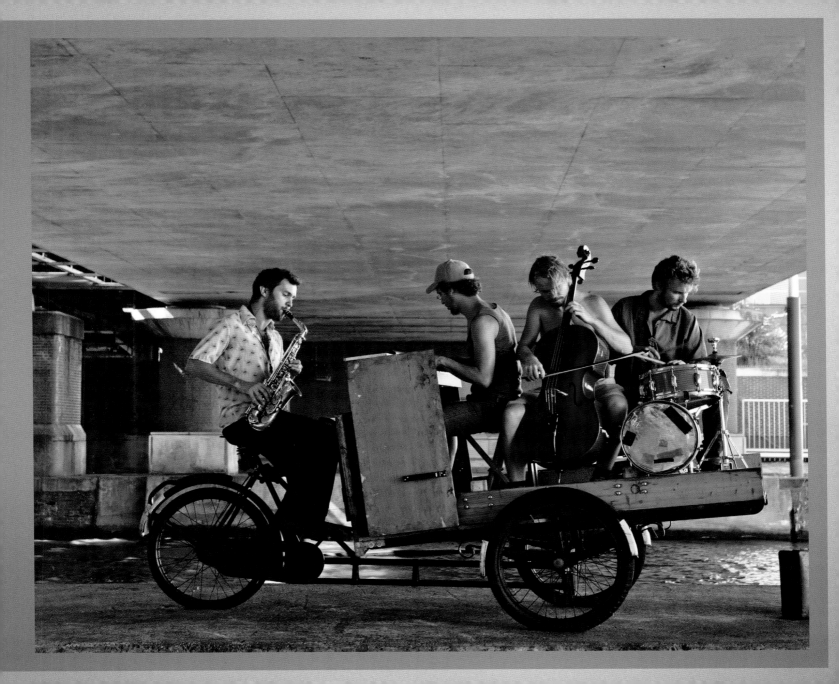

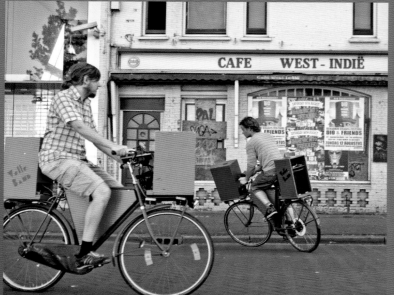

# volle band

Amsterdam's Volle Band have added special brackets to install sound, image and computer modules on various styles of bike to facilitate a wide range of audiovisual productions. Data can also be transferred wirelessly between the bicycles, and sensors on each bike are used to turn them into dynamic instruments. However, simpler setups occur when two sound bicycles play musical pieces that complement each other.

# magnificent revolution

'It's all too easy to flick a switch and watch a full kettle boil, when in fact often only a fraction of that water is needed for your morning brew. It's just force of habit – hardly a consideration is given to what natural resource was used in the generation of that power which comes so easily to us. More thought would be put into your energy consumption if you had to cycle for 60 minutes to provide that three kilowatts of kettle energy. The humble bicycle puts it in simple tangible terms – effort in equals power out,' explains Adam from the not-for-profit educational collective Magnificent Revolution.

Since 2007 Magnificent Revolution have been educating people to be actively aware of their energy consumption and how they can make a real difference to the environment through renewable technologies, low-carbon living and by building their own micro-generation power plants.

'The Cycle-In Cinema is exactly what it says. We promote and hold cinema events in varied locations in and around London. Audiences cycle to the cinema, hook their bike into the generator, then pedal to provide the energy required for the film's projector and sound system. With 20 bikes we can provide up to one kilowatt of free energy.

'The cinema is designed to educate as well as entertain, so within view of the cinema-goers is a display system showing how much power they're producing and consuming. What better way to enjoy a film and at the same time work off the calories from the ice cream and popcorn!'

## street books

'We're a bicycle-powered mobile library for people living outside,' explains Laura Moulton, a mother of two, writer and founder of Street Books. 'No due date or fee for a late return – my patrons have enough to deal with on a daily basis. Unlike a regular library, you don't have to provide me with any identification, or proof of address. The library works purely on trust. Patrons are surprised to learn that a book can be borrowed with nothing more than their signature on an old school library card, the proviso being that they agree to bring the book back when finished. And bring it back they do – despite those who said early on I would never see the books again. I've had a few patrons come and find me to apologise that a book they borrowed has been stolen or damaged by rain – I'm touched by their concern. When they do return their books they often linger to tell me about their experience reading it. These are important conversations to have because, in the end, it's just two people discussing a good book.

'Just because they live outside doesn't mean they're less intelligent, articulate or hungry for knowledge; for some, life just threw them a curve ball. Many held down stable jobs but, inexplicably,

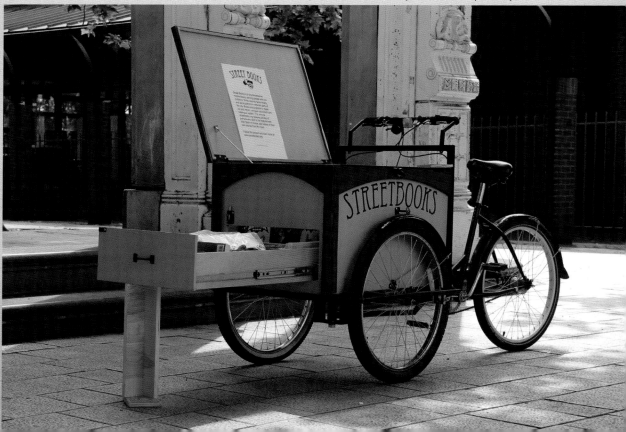

a change of fortune led to a life on the streets. For myself and others we know first-hand the power of a good read and the escapism it can bring. We take for granted walking into a bookstore and buying a book or using a local library – why shouldn't those who live outside on the streets have the same access?'

Without fail, twice a week or more Laura, with her elegantly designed custom-made work bike loaded with books, cycles into downtown Portland, Oregon. 'Not being at the agreed location on time for my patrons isn't an option. Street Books is a fixture in their lives, I provide structure and routine to those who have little or none.

'Street Books has been successful due to the amazing support from the community and my patrons. I've hired other street librarians to help me and we've had a lot of interest from people in other cities who want to start their own street libraries. My patrons may not be rich in possessions but are rich in knowledge.'

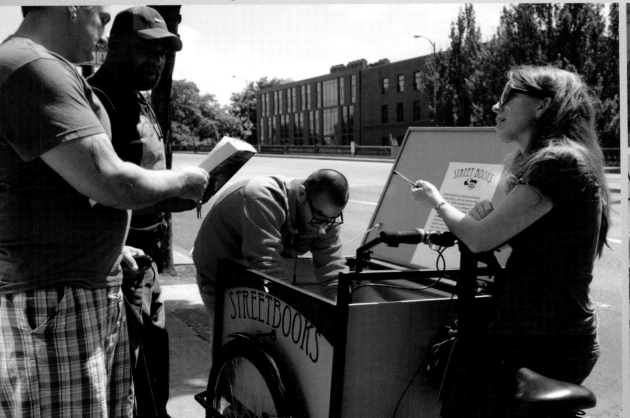

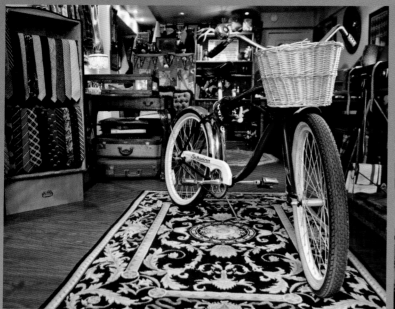

# dandy 911

Dandy 911 is an emergency delivery service of New York City's men's accessories store Fine and Dandy – there to handle all your clothing disasters. Matt Fox, proprietor of the store, credits his grandfather for his love of fine clothing. 'Style has no rules. Mix and match. Wear whatever ever you love. And most importantly, don't be afraid to show a little flair,' says Matt.

Supplier of 'accessories for dapper guys', he is just a phone call away after a clothing calamity. With his new – but vintage-inspired – Schwinn delivery bicycle, he will rush to your aid with perhaps a cummerbund, handkerchief, pocket square, tie or maybe a pair of socks. Manhattan from 14th to 89th Street has never been in safer hands.

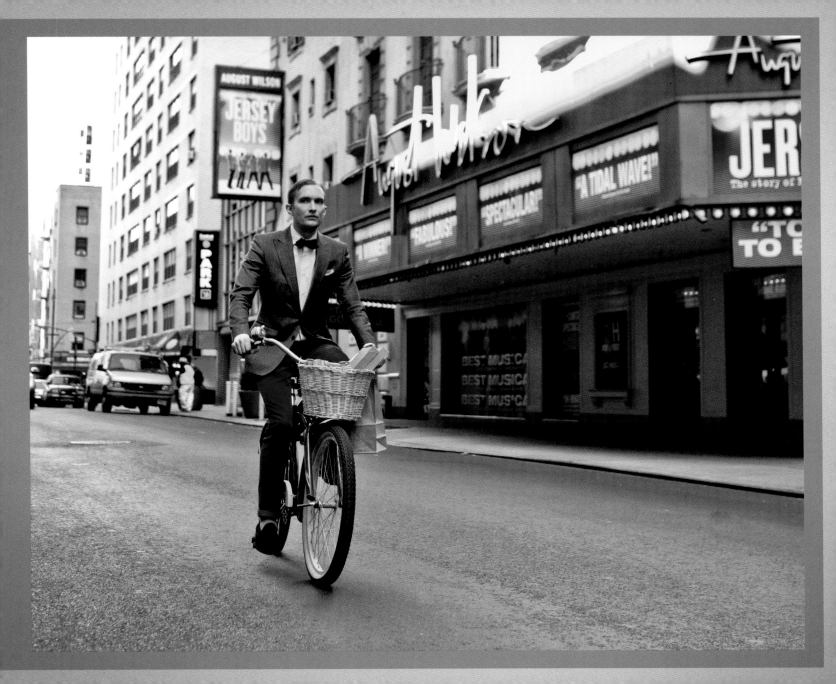

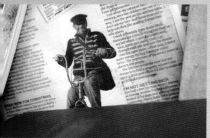

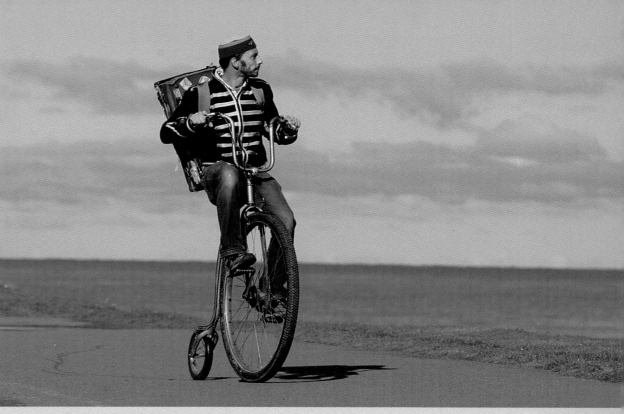

# penny-farthing post

'I'm a victim of my own success. I didn't want to end the business, especially when it was going so well, but reluctantly I had to call it a day, much to the relief of my weary legs. Added to that I was hardly at home and even the penny-farthing was wearing out!' explains Graham Eccles, a performance artist who in his home town of Bude, Cornwall, took on the mighty postal service. Graham had seen the special one-off penny farthing with its Chopper-style handlebars online and bought it on a whim long before he decided to take on the Post Office.

'It could hardly be considered a serious attempt to dent Royal Mail's market share of around a gazillion letters per day. The Penny Farthing Post was only intended to be a bit of fun, a jovial one-man rebellion against the sharp increase in a Royal Mail first-class stamp in April 2012. However, with my equivalent stamp costing only 25 pence, things started to pick up. I even designed and printed my own stamp, the 'Penny Farthing Black'. Local shops served as drop-off locations for letters, then followed my own bright yellow postboxes made from old gas cylinders. After the last collection of the day it was home to sort the letters for next day's delivery, a process not made easy by my two young children's offers of help! At my peak I was delivering over 150 letters a day on my carefully thought-out 15-mile route. My life as a postman may have been short, but it was hugely enjoyable – I ended on a high.'

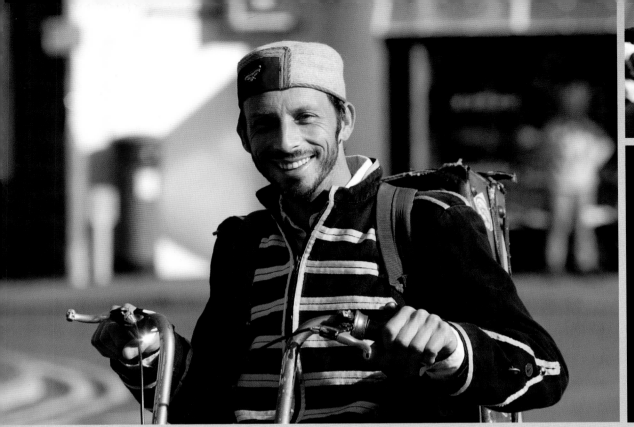

Bude
Penny Farthing Post
LETTERS
Six Days A Week
Next Day Delivery
All For The FAIR Price Of
Only 25 Pence
Collections
Monday thru Saturday
rom BUDE Town
day, Wednesday & Friday Collections
m Marhamchurch & Widemouth
our Local Penny Farthing Post Stamp Retailer For Details
or contact us

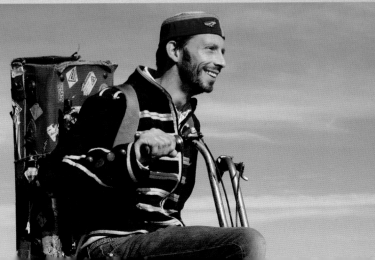

## beam bike

'Our aim is to capture a public space through audiovisual techniques and show people how versatile bicycles can be, as well as making our audience more aware of the possibilities and beauty of public spaces,' explain Didier and Daan Dirk, founder members of Amsterdam's Volle Band, an art-based project in Amsterdam consisting of bicycles that perform in public spaces.

Didier continues, 'It started when we both retrofitted an old caravan with 20 television sets pointing outwards through windows and holes in the walls. To make our performances more mobile, we added a small television to the handlebars of a bike. We then joined forces with Sjoerd, who studied composition and music technology; Olle, who studied philosophy and medicine; and Zac, who is a classically trained guitarist from Australia. We all came together as a group during our studies in Amsterdam – often meeting at the infamous Kwikfiets bicycle repair shop...the starting point for many artistic collaborations.

'Together we expanded on the mobile idea by developing a set of multimedia bicycles to perform all manner of audiovisual public performances. Our beam bike, a modified cargo bike which we lovingly call "The Mothership", is decked out with built-in modules that can facilitate a combination of one or two projectors, a set of speakers with audio mixer, a small computer and two large lights doubling up as headlights, a legal requirement for any bike in Holland, as well as lighting for performances at dark locations.' The projectors, called 'beamers' in Dutch (in a form of faux English, I suppose), give the beam bike its name. 'The bicycles make us empathic to the public; we don't just put a loud PA system on the street to annoy.'

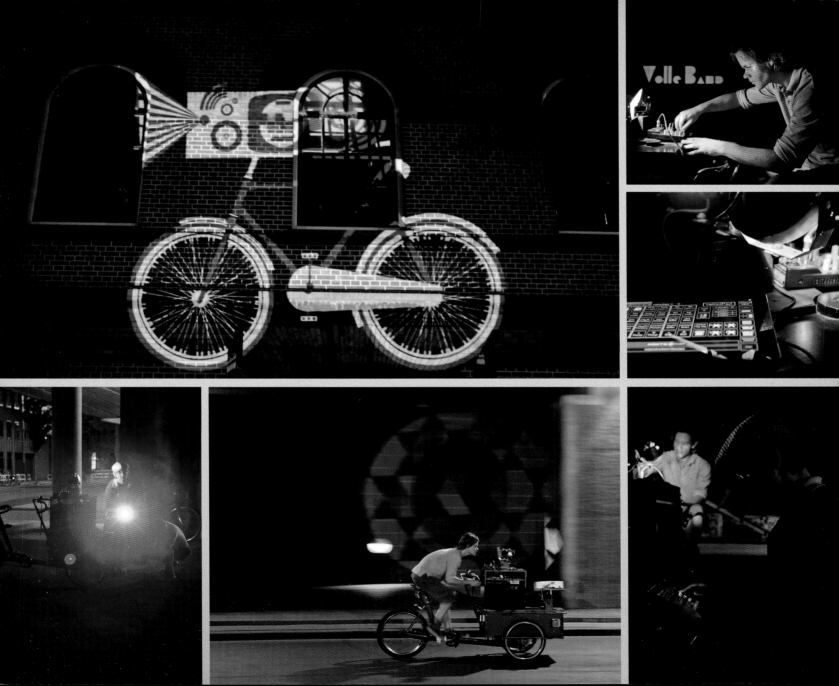

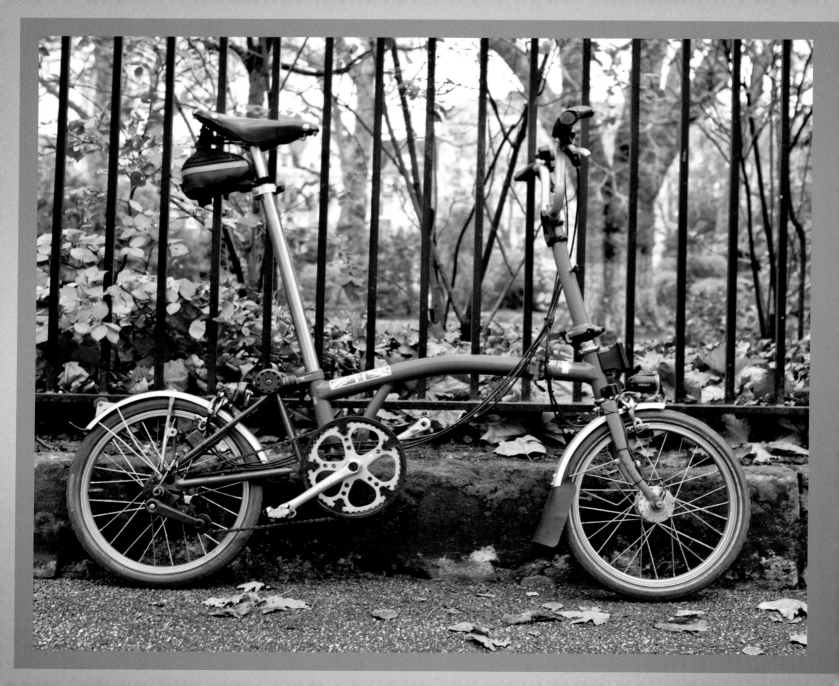

# the brompton

'My first bicycle was a Raleigh Chipper...not a Chopper – although I wished it was! Cycling remained just a pastime during my teens and early adult years. However, my love for cycling was rediscovered when I was transferred to the Metropolitan Police Service,' explains Sergeant Titus Halliwell. 'I commuted to work via train, so to hasten my journey to and from the station I decided to buy a Brompton folding bike. The bike is simple and comes with a passionate community of fellow owners; a great place to discuss ownership of the quintessentially British invention.

'Sadly, my first one was stolen; ironic considering I now run the Met's Tfl-funded Cycle Task Force. We're a team of 30 officers cracking down on bicycle theft. It's not just opportunist thieves behind the alarming statistics of over 21,000 bikes being stolen last year. More often it's organised gangs that are making significant incomes from the misery and inconvenience of bike theft. As well as encouraging good locking practices, our mantra is the three Rs; Record, Register and Report. Record details of your bike's frame number, register it online at www.BikeRegister.com and report thefts to the police. My choice of bike was vindicated after a two-day cycle ride from London to Paris to see the Tour de France. On the return journey, I could carry the Brompton on the train as hand luggage, while my companions had somewhat more difficulty.'

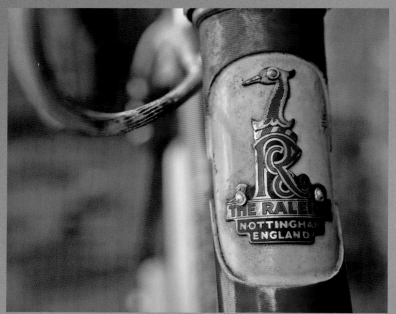

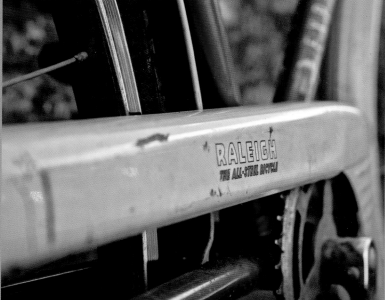

# raleigh explorer

Raleigh's Space-Race-inspired Explorer bicycle, complete with ear-splitting Pifco Super Sonic bicycle hooter, is an example of a classic 1950s Roadster, built for durability and a bare minimum of maintenance, hence its single speed. No attempt has been made to save weight in either design or construction. Note the North Road handlebars, leather saddle with springs and the famous heron logo on the headbadge.

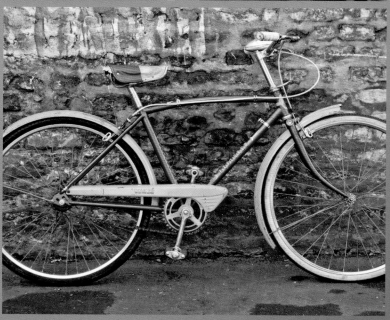

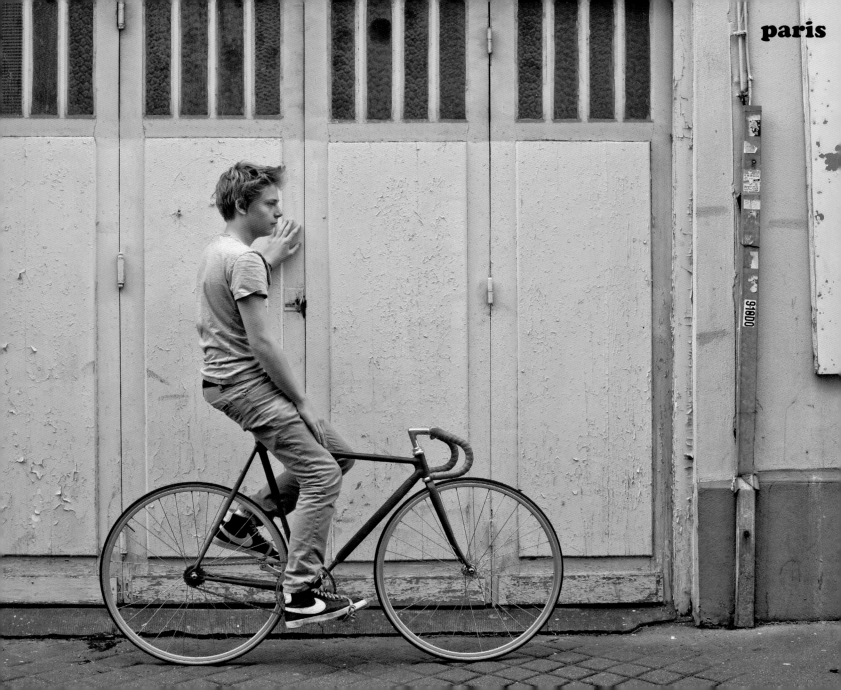
paris

# sourcebook

## bike shops

**The Bicycle Library**
www.215w11.com/bicyclelibrary

**Brixton Cycles**
www.brixtoncycles.co.uk

**Chopperdome**
www.thechopperdome.com

**Cyclope Bikes**
www.cyclopebikes.fr

**En Selle Marcel**
www.ensellemarcel.com

**Exceller Bikes**
www.excellerbikes.com

**Fahrradhof Altlandsberg**
www.aufs-rad.de

**Horse Cycles**
www.horsecycles.com

**Ichi Bike**
www.ichibike.com

**The Old Bicycle Company**
www.theoldbicycleshowroom.
co.uk

**Sargent & Co.**
www.sargentandco.com

**Tokyo Fixed Gear**
www.tokyofixedgear.com

**Vélo Vintage**
www.velo-vintage.com

**718 Cyclery**
www.718c.com

## cycle fashion and accessories

**Always Riding**
www.alwaysriding.co.uk

**Bicycle Decals**
www.bicycledecals.net

**Brooks England**
www.brooksengland.com

**Contour**
www.contour.com

**Le Coq Sportif**
www.lecoqsportif.com

**Rapha**
www.rapha.cc

**Swrve**
www.swrve.co.uk

**TWO n FRO**
www.215w11.com

**Urban Spokes**
www.urbanspokes.com

## cycle manufacturers

**Brompton**
www.brompton.co.uk

**Johnny Coast**
www.johnnycoast.com

**Koga**
www.koga.com

**Mercian**
www.merciancycles.co.uk

**Pashley**
www.pashley.co.uk

**Raleigh**
www.raleigh.co.uk

## environment and community

**Bicycle Aid for Africa**
www.re-cycle.org

**Magnificent Revolution**
www.magnificentrevolution.org

**Street Books**
www.streetbooks.org

**Volle Band**
www.volleband.nl

## recreation

**The Bikerist**
www.thebikerist.com

**Cycling holidays**
www.skedaddle.co.uk

**The Guvnors' Assembly**
www.theguvnorsassembly.com

**Lock 7 Cycle cafe**
www.lock-7.com

**Star Bikes Rental Amsterdam**
www.starbikesrental.com

**Tally Ho Cycle Tours**
www.tallyhocycletours.com

**The Tweed Run**
www.tweedrun.com

## reference and inspiration

**BSA folding bike**
www.bsabikes.co.uk

**Classic Lightweights**
www.classiclightweights.co.uk

**Classic Rendezvous**
www.classicrendezvous.com

**The Folding Society**
www.foldsoc.co.uk

**Historic Hetchins**
www.hetchins.org

**London Fixed-gear and Single-speed Forum**
www.lfgss.com

**National Cycle Collection**
www.cyclemuseum.org.uk

**The Raleigh Chopper Owners Club**
www.rcoc.co.uk

**The Veteran Cycle Club**
www.v-cc.org.uk

**Vintage Schwinn**
www.vintageschwinn.com

## security and safety

**Bike Register**
www.bikeregister.com

**Giro cycle helmets**
www.giro.com

**Hiplok**
www.hiplok.com

**The invisible bicycle helmet**
www.hovding.com

## sport and challenges

**Fundraising and recreational cycle rides**
www.bike-events.com

**Herne Hill Velodrome**
www.hernehillvelodrome.com

**L'Eroica**
www.eroicafan.it

**London Hardcourt Bike Polo Association**
www.lhbpa.org

**The man who cycled the world**
www.markbeaumontonline.com

**Penny-Farthing World Tour**
www.pennyfarthingworldtour.com

**Rollapaluza**
www.rollapaluza.com

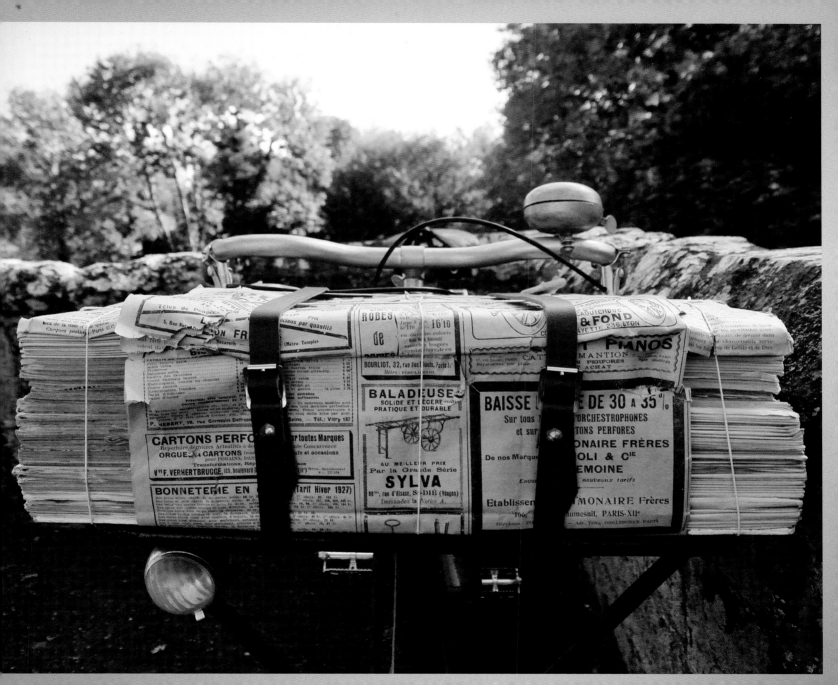

# credits

We would like to thank all the owners for allowing us
to photograph their 'cool bikes'.

All photography by Lyndon McNeil unless otherwise stated.
www.lyndonmcneilphotography.com

## bringing together
Pages 14–17 Briggy's Bike Shack, Briggy, London
Pages 18–19 Fixed 'n' Chips, Gavin Strange, Bristol (Photography by Gavin Strange,
BÖIKZMÖIND, www.boikzmoind.com)
Pages 20–21 The Thursday Club, John Rhodes, West Midlands
Pages 22–23 Horse Cycles, Thomas Callahan, Brooklyn, New York
Pages 24–25 The Co-operative, Brixton Cycles, London
Pages 26–28 The Old Bicycle Company, Tim Gunn, Essex
Pages 29–31 The Classic Riders Club, Brooklyn, New York
Pages 32–35 The Ministry of Bicycles, Bill Pollard, Northampton (photography by Lyndon
McNeil and Steve Rideout, www.rideoutphoto.co.uk)
Pages 36–37 The Inverted Bike Shop, 718 Cyclery, Joseph Nocella, Brooklyn, New York
Pages 38–39 The Bicycle Library, Karta Healy, London
Pages 40–41 Chopperdome, Amsterdam
Pages 42–43 Sargent & Co, Rob Sargent, London
Pages 44–45 Benjamin Cycles, Ben Peck, Brooklyn, New York
Pages 46–48 Ichi Bike, Daniel Koenig, Iowa (photography by Jill Brown,
www.jillbrownphotography.com)
Page 49 Star Bikes Café, Linda Pluimers, Amsterdam
Pages 50–51 Pashley Guv'nors, The Guv'nors' Assembly, Adam Rodgers
Pages 52–53 Kwikfiets, Willem, Amsterdam
Page 54 Burning Man, Nevada (photography by Marc van Woudenberg www.
amsterdamize.com)
Page 55 The Bikerist, Etaïnn Zwer, Paris (photography by The Bikerist,
Jérémy Beaulieu www.thebikerist.com)
Page 56 En Selle Marcel, Bruno Urvoy, Paris
Page 56 Lock 7, London
Page 57 Fahrradhof Altlandsberg, Peter Horstmann, Germany (photography by
Oliver Schulze www.fotokamikaze.de)
Page 57 Exceller Bikes, Christian Campers, Bruges

## because i can
Pages 60–63 The Man who Cycled the World, Mark Beaumont, Perthshire. Scotland
(Photography by Chris Haddon)
Pages 65–65 Bike Polo, London Hardcourt Bike Polo Association
Pages 66–67 The Olympian, Tommy Godwin, Solihull, West Midlands
Pages 68–69 Hillbilly, Jim Sullivan, London
Pages 70–71 L'Eroica, Italy (Photography by Angelo Ferrillo
www.ferrilloshots.it)
Pages 72–73 Brixton Billy, William Prendergast, London
Pages 74–75 Penny-Farthing World Tour, Joff Summerfield, London
Page 76 Herne Hill Velodrome, Herne Hill, London
Page 77 Rollapaluza, London (photography by Rollapaluza Outreach, Little Monstas
Fundraiser Event www.rollapaluza.org)

## the mavericks
Pages 82–85 Cally, Count Martindt Cally Von Callomon, Suffolk
Pages 86–87 The Designer, Tom Karen, Cambridge
Pages 88–90 The Urban Voodoo Machine, Paul-Ronney Angel, Lady Ane Angel, London
Page 91 Yasi and Roy, Yasemin Richards, London
Pages 92–93 Urban Assault Kurb Krawler, Neil Stanley, Essex
Pages 94–97 Toon, Toon Boumans, Cuyk, Holland
Pages 98–100 The Yellow Jersey, Sir Paul Smith, London
Page 101 Lejeune, Sucre d'Orge, Paris
Pages 102–103 Alan Super Gold, John Abrahams, Leamington Spa, Warwickshire
Pages 104–107 Royal Mail Special Delivery, Elizabeth Jose, Brooklyn, New York
Pages 108–111 Schwinn, Estelle Bilson, Bedfordshire
Pages 112–114 Raleigh Chopper, Norman Jay MBE, London
Pages 115–117 Matteo, Matteo Scialom, Paris. Photographed at
www.lecomptoirgeneral.com
Pages 118–120 Days Gone By, Simon and Wendy Doughty, Market Harborough,
Leicestershire
Page 121 Vélo Vintage, Hugo Badia, Edson Delgado, Paris
Pages 122–125 The Perfectionist, Guy Lesser, Brooklyn, New York
Pages 126–127 An Affair with Phillips, Hannah Newham, London
Pages 128–129 Gaskill's Hop Shop, Adam Gaskill, Murfreesboro, Tennessee
(photography by Daniel Youree Lewis)
Page 130 BSA Folding Bike, Vernon Crisp, Essex
Page 131 Mizutani Super Cycle, Bruno Urvoy, Paris
Page 132 Elswick-Hopper Scoo-Ped, David Gray, Middlesex (photography by Chris
Haddon)
Page 132 Charrie's Café, CharRie's Café, Rie Sawada, Berlin, Germany
(photography by Rie Sawada)
Page 133 Nuclear Bunker Tunnel, Kelvedon Hatch, Essex
Page 133 Critérium des Porteurs de Journaux, Miq Keeland, West Sussex
(photography by Chris Haddon)

## making a difference
Pages 136–138 Re-Cycle, Derek Fordham, Essex (photography by Lyndon McNeil and
Jason Finch)
Page 139 Beijing Cargo Bicycles, Chaoyang, Beijing, China
(photography by Nathaniel McHahon www.nathanielmcmahon.com)
Pages 140–141 The Bike Band, De Bakfiets Band, Amsterdam
Page 142 Volle Band, Amsterdam
Page 143 Magnificent Revolution, Adam Walker, London
Pages 144–145 Street Books, Laura Moulton, Portland, Oregon
(photography by Jodi Darby www.jodidarby.com)
Pages 146–147 Dandy 911, Fine and Dandy, Matt Fox, Manhattan, New York
Pages 148–149 Penny-Farthing Post, Graham Eccles, Bude, Cornwall
(photography by Chris Haddon)
Pages 150–151 Beam Bike, Amsterdam
Page 152–153 The Brompton, Titus Halliwell, London
Page 154 Raleigh Explorer
Page 155 Cyclops Bikes, Paris

# acknowledgements

I never assume anything is a certainty in life, so when given yet another opportunity to delve into a new topic for the my cool… series I counted myself lucky. This book really was a joy to produce and we've met some truly amazing, humbling and inspiring individuals. Bikes really do bring out the best in people.

However, the book would not have been possible without the help and support of so many; thank you to everyone who appears in the book. With special thanks to those New Yorkers who didn't let me down, despite dealing with the aftermath of Hurricane Sandy. As ever, my gratitude to Pavilion Books, especially my commissioning editor Fiona Holman and designer Georgina Hewitt for the faith and support you have invested in me.

Thank you, Lyndon. Once again you've gone above and beyond the call of duty, capturing the true essence of those in the book. Thanks to Maureen Hunt and to my wonderful daughters Imogen and Gracie (a budding photographer in her own right – watch out, Lyndon, she's hot on your heels).

Both Lyndon and I are indebted to our wives Sarah and Emma for their unwavering support. In September 2012 Lyndon McNeil and Sarah Bull wed in Siena, Italy. It was a pleasure to be there and I even allowed Lyndon time off from our busy schedule for a honeymoon – I'm just all heart.

Finally, Lyndon and I would like to dedicate this book to our fathers, David and Tony, who diligently spent many hours teaching us to ride our bikes.

## chris haddon

Chris Haddon is a designer with over 20 years' experience. He has a huge passion for all things retro and vintage. Among his collection is his studio, which is a converted 1960s Airstream from where he runs his design agency.

**Additional captions: page 1 raleigh chopper; pages 2–3 chopperdome; page 4 hobbs; page 6 the classic riders club; page 9 briggy's bike shack; page 12 the ministry of bicycles; page 58 penny farthing world tour; page 80 schwinn; page 134 dandy 911; page 157 critérium des porteurs des journaux; page 160 the thursday club**

First published in 2013 by Pavilion Books
An imprint of Anova Books Company Ltd
10 Southcombe Street
London W14 0RA

www.anovabooks.com

Commissioning editor Fiona Holman
Photography by Lyndon McNeil
Styling by Chris Haddon
Design Steve Russell
Editor Ian Allen

Text copyright © Chris Haddon 2013
Design copyright © Pavilion Books 2013

All rights reserved. No part of this book may be reproduced or utilised in any form by any means, electronic or mechanical, including photocopying, recording or by any information storage and retrieval system, without the prior written permission of the publishers.

A CIP catalogue for this book is available from the British Library

ISBN 978-1-862-05961-0

10 9 8 7 6 5 4 3 2 1

Colour reproduction by Dot Gradations Ltd, UK
Printed and bound by 1010 Printing International Ltd in China

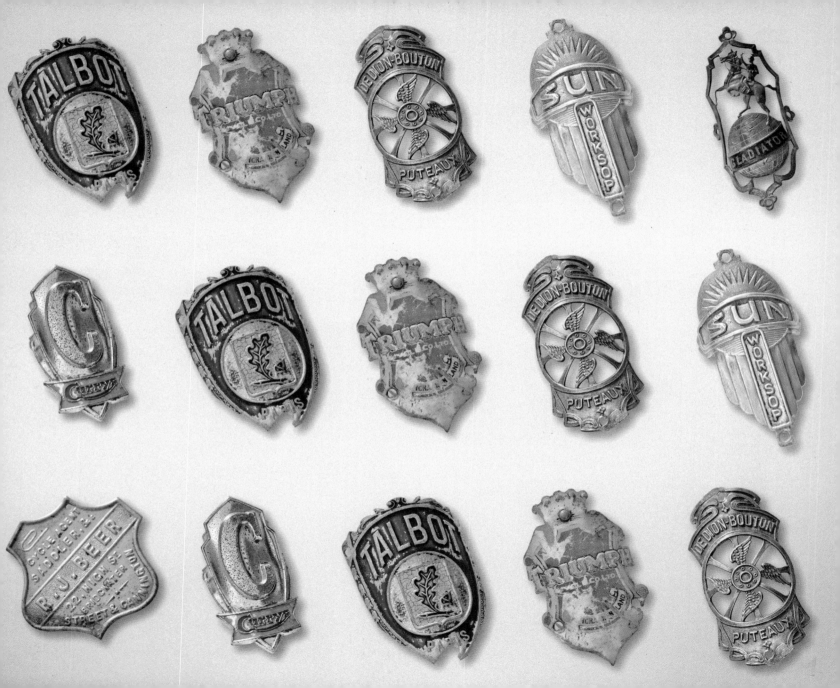